SiMPSONS

COMICS

SUPERNOVA

HARPER

NEW YORK · LONDON · TORONTO · SYDNEY

SIMPSONS COMICS SUPERNOVA

Collects Simpsons Comics 81, 101, 102, 103, and The Simpsons Summer Shindig #2

Copyright © 2013 by
Bongo Entertainment, Inc. All rights reserved.
No part of this book may be used or reproduced in any manner whatsoever
without written permission except in the case of brief quotations
embodied in critical articles and reviews. For information address
HarperCollins Publishers,
10 East 53rd Street, New York, NY 10022.

FIRST EDITION

ISBN 978-0-06-225438-2

13 14 15 16 17 TC 10 9 8 7 6 5 4 3 2 1

Publisher: Matt Groening
Creative Director: Bill Morrison
Managing Editor: Terry Delegeane
Director of Operations: Robert Zaugh
Art Director: Nathan Kane
Art Director Special Projects: Serban Cristescu
Production Manager: Christopher Ungar
Assistant Art Director: Chia-Hsien Jason Ho
Production/Design: Karen Bates, Nathan Hamill, Art Villanueva
Staff Artist: Mike Rote
Administration: Ruth Waytz, Pete Benson
Editorial Assistant: Max Davison
Legal Guardian: Susan A. Grode

Printed by TC Transcontinental, Beauceville, QC, Canada. 12/15/12

CONTENTS

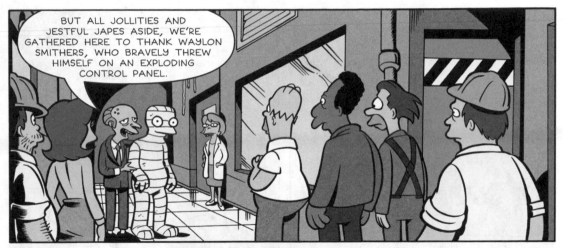

BUT ALL JOLLITIES AND JESTFUL JAPES ASIDE, WE'RE GATHERED HERE TO THANK WAYLON SMITHERS, WHO BRAVELY THREW HIMSELF ON AN EXPLODING CONTROL PANEL.

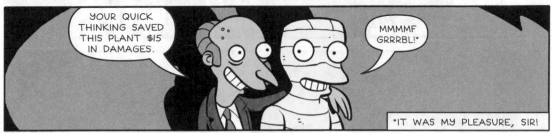

YOUR QUICK THINKING SAVED THIS PLANT $15 IN DAMAGES.

MMMMF GRRRBL!*

*IT WAS MY PLEASURE, SIR!

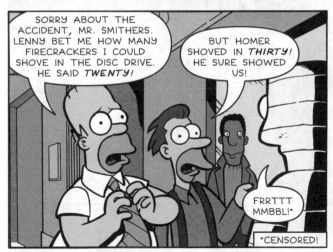

SORRY ABOUT THE ACCIDENT, MR. SMITHERS. LENNY BET ME HOW MANY FIRECRACKERS I COULD SHOVE IN THE DISC DRIVE. HE SAID *TWENTY*!

BUT HOMER SHOVED IN *THIRTY*! HE SURE SHOWED US!

FRRTTT MMBBL!*

*CENSORED!

HEY, MR. SMITHERS, CAN I SIGN YOUR BODYCAST?

YES! YES, *EVERYONE* LINE UP TO SIGN THE CAST!

AND SO BY SIGNING THE CAST EVERYONE WAVES THEIR RIGHTS TO SUE THE PLANT IN CASE OF ANY *FUTURE* ACCIDENTS OR GROSS NEGLIGENCE?

I INCLUDED SOME FINE PRINT ON MR. SMITHERS' BEHIND, MAKING HIM A STANDARD NONDISCLOSURE CONTRACT.

SO SORRY YOU WON'T BE ABLE TO COME ON OUR ANNUAL SUMMER VACATION *TREASURE HUNT*, OLD MAN. I KNOW HOW YOU ENJOY THEM.

BUT THE IMPORTANT THING IS FOR YOU TO GET THE BEST MEDICAL CARE THIS PLANT PROVIDES.

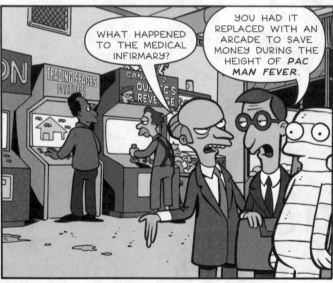

WHAT HAPPENED TO THE MEDICAL INFIRMARY?

YOU HAD IT REPLACED WITH AN ARCADE TO SAVE MONEY DURING THE HEIGHT OF *PAC MAN FEVER*.

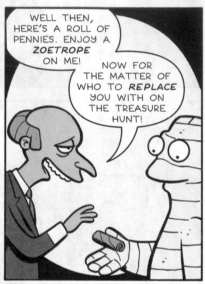

WELL THEN, HERE'S A ROLL OF PENNIES. ENJOY A *ZOETROPE* ON ME!

NOW FOR THE MATTER OF WHO TO *REPLACE* YOU WITH ON THE TREASURE HUNT!

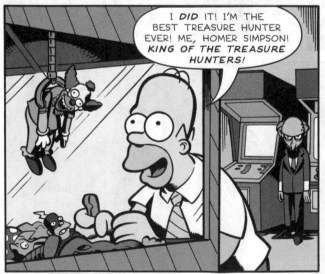

I *DID* IT! I'M THE BEST TREASURE HUNTER EVER! ME, HOMER SIMPSON! *KING OF THE TREASURE HUNTERS!*

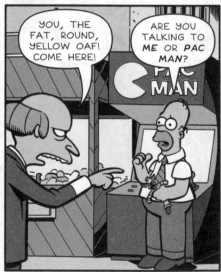

YOU, THE FAT, ROUND, YELLOW OAF! COME HERE!

ARE YOU TALKING TO *ME* OR *PAC MAN?*

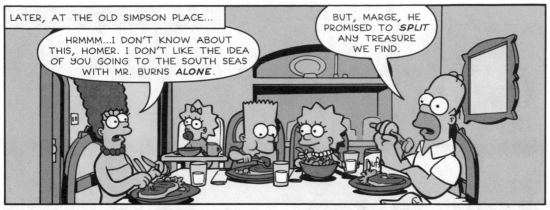

LATER, AT THE OLD SIMPSON PLACE...

HRMMM...I DON'T KNOW ABOUT THIS, HOMER. I DON'T LIKE THE IDEA OF YOU GOING TO THE SOUTH SEAS WITH MR. BURNS *ALONE*.

BUT, MARGE, HE PROMISED TO *SPLIT* ANY TREASURE WE FIND.

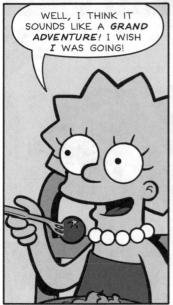

WELL, I THINK IT SOUNDS LIKE A *GRAND ADVENTURE!* I WISH *I* WAS GOING!

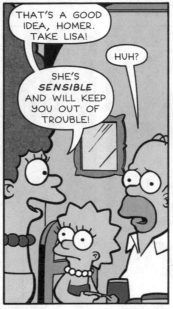

THAT'S A GOOD IDEA, HOMER. TAKE LISA!

HUH?

SHE'S *SENSIBLE* AND WILL KEEP YOU OUT OF TROUBLE!

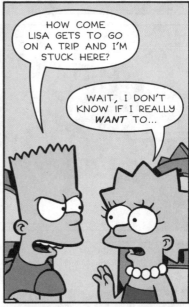

HOW COME LISA GETS TO GO ON A TRIP AND I'M STUCK HERE?

WAIT, I DON'T KNOW IF I REALLY *WANT* TO...

YOU'RE RIGHT! HOMER TAKE *ALL* THE KIDS WITH YOU. LUCKILY, I JUST HAPPENED TO PACK ALL YOUR BAGS THIS AFTERNOON.

IF ANYONE NEEDS ME, I'LL BE AT THE RANCHO RELAXO SPA!

SLAM!

VRRRROOOOOM!

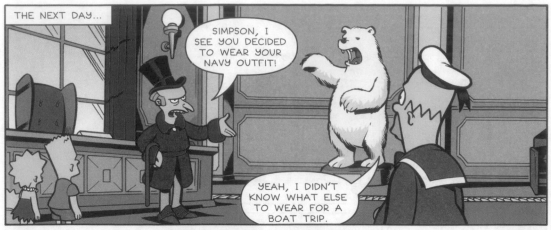

THE NEXT DAY...

SIMPSON, I SEE YOU DECIDED TO WEAR YOUR NAVY OUTFIT!

YEAH, I DIDN'T KNOW WHAT ELSE TO WEAR FOR A BOAT TRIP.

AND THE REASON YOU'RE NOT WEARING *PANTS*?

MARGE IS AT THE SPA, AND I DON'T KNOW HOW TO WORK THE WASHING MACHINE.

SHUDDER! SEE SHEILA IN PETTY CASH AND PETTY OFFICER WEAR. SHE'LL ISSUE YOU A SET OF *TROUSERS!*

YES, SIR!

AND HE BROUGHT ALONG *CHILD LABOR!* MARVELOUS! SO WHO MIGHT YOU URCHINS BE?

I'M LISA. THIS IS MAGGIE AND BART.

NO, I'LL NEVER REMEMBER THAT. ALL YOU CHILDREN LOOK ALIKE TO ME.

HERE, PUT ON THESE COLOR-CODED OUTFITS TO KEEP THINGS SIMPLE!

EXCELLENT, NOW WE'RE OFF FOR SUPPLIES! MAKE HASTE!

THERE'S SOMETHING *HUEY, DEWEY, AND SCREWY* ABOUT ALL THIS!

LATER...

AHOY-HOY, PROFESSOR!

I'LL BE RIGHT WITH YOU, MR. BURNS!

FOR GLAVIN'S SAKE, F.L.O., HOLD THE TACHYON RACKET *STEADY*. WE MUST KEEP THE TIME VORTEX *STABILIZED!*

WHAT'S THAT?

OH, THAT'S F.L.O.! MY FLORESCENT LIGHT-BASED OFFICE ASSISTANT!

NO, F.L.O.! KEEP BOTH HANDS ON THE RACKET!

OH, THAT IS JUST ≡GAH-VEN≡ WONDERFUL!

WELL, I'LL TELL YOU, F.L.O., I AM NOT GOING TO BE THE ONE CLEANING UP *PTERODACTYL POOP!*

WE'RE IN A HURRY, PROFESSOR!

OH, OF COURSE. SORRY. RIGHT THIS WAY!

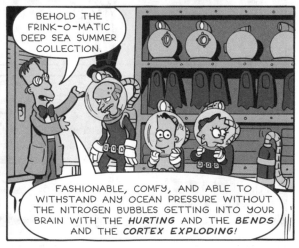

BEHOLD THE FRINK-O-MATIC DEEP SEA SUMMER COLLECTION.

FASHIONABLE, COMFY, AND ABLE TO WITHSTAND ANY OCEAN PRESSURE WITHOUT THE NITROGEN BUBBLES GETTING INTO YOUR BRAIN WITH THE *HURTING* AND THE *BENDS* AND THE *CORTEX EXPLODING!*

IT'S ≥GASP≥ A BIT ≥GAK≥ TIGHT!

DAD, I THINK YOU AND MAGGIE HAVE EACH OTHER'S SUITS!

THUD!

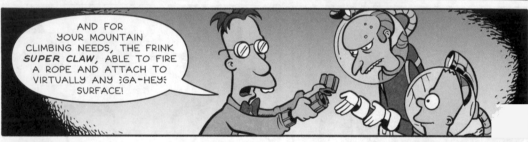

AND FOR YOUR MOUNTAIN CLIMBING NEEDS, THE FRINK *SUPER CLAW,* ABLE TO FIRE A ROPE AND ATTACH TO VIRTUALLY ANY ≥GA-HEY≥ SURFACE!

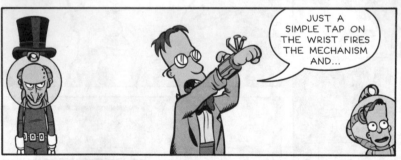

JUST A SIMPLE TAP ON THE WRIST FIRES THE MECHANISM AND...

OH DEAR.

PTANNG!

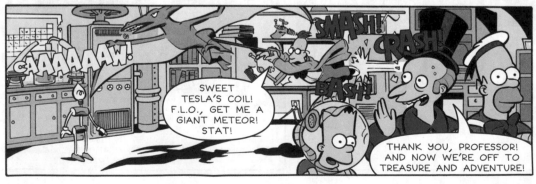

CAAAAAAW!

SMASH!

CRASH!

BASH!

SWEET TESLA'S COIL! F.L.O., GET ME A GIANT METEOR! STAT!

THANK YOU, PROFESSOR! AND NOW WE'RE OFF TO TREASURE AND ADVENTURE!

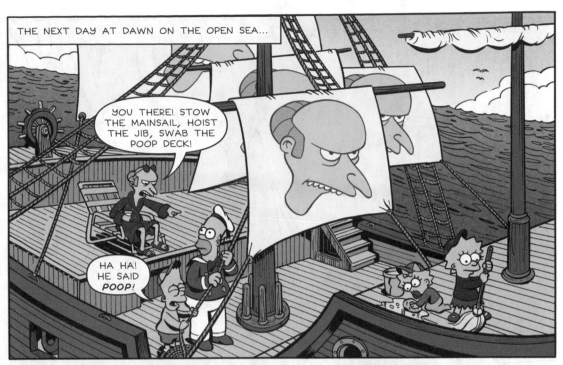

YOU THERE! STOW THE MAINSAIL, HOIST THE JIB, SWAB THE POOP DECK!

HA HA! HE SAID *POOP!*

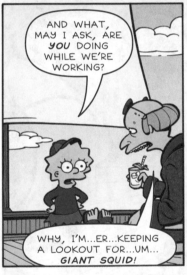

AND WHAT, MAY I ASK, ARE *YOU* DOING WHILE WE'RE WORKING?

WHY, I'M...ER...KEEPING A LOOKOUT FOR...UM... *GIANT SQUID!*

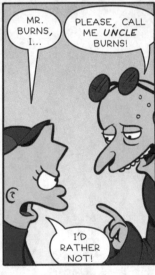

MR. BURNS, I...

PLEASE, CALL ME *UNCLE* BURNS!

I'D RATHER NOT!

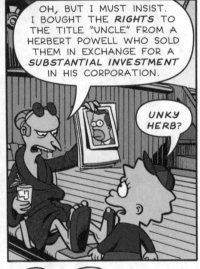

OH, BUT I MUST INSIST. I BOUGHT THE *RIGHTS* TO THE TITLE "UNCLE" FROM A HERBERT POWELL WHO SOLD THEM IN EXCHANGE FOR A *SUBSTANTIAL INVESTMENT* IN HIS CORPORATION.

UNKY HERB?

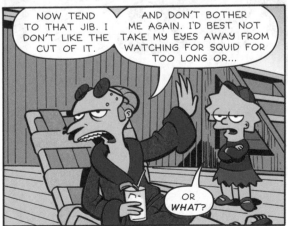

NOW TEND TO THAT JIB. I DON'T LIKE THE CUT OF IT.

AND DON'T BOTHER ME AGAIN. I'D BEST NOT TAKE MY EYES AWAY FROM WATCHING FOR SQUID FOR TOO LONG OR...

OR *WHAT?*

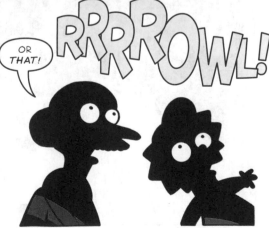

OR *THAT!*

RRRROWL!

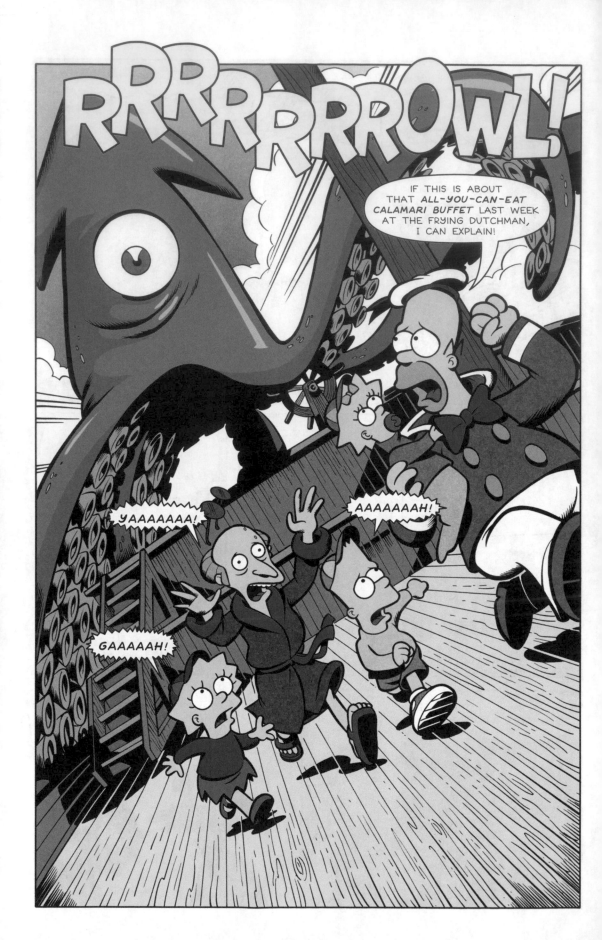

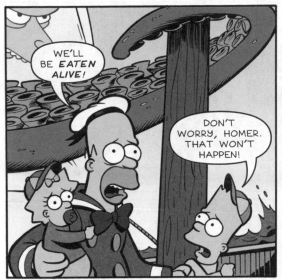

WE *DID* IT!

DID WHAT?

WHAT THE--?!

THWACK!

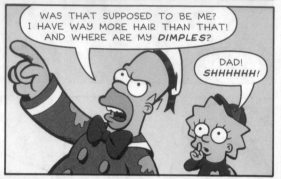

WAS THAT SUPPOSED TO BE ME? I HAVE WAY MORE HAIR THAN THAT! AND WHERE ARE MY *DIMPLES*?

DAD! *SHHHHHH!*

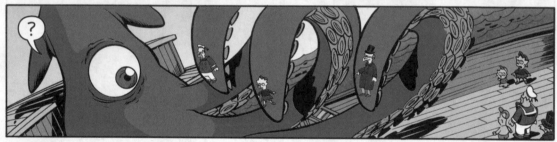

?

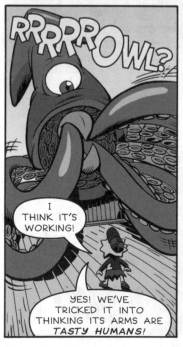

RRRRROWL?

I THINK IT'S WORKING!

YES! WE'VE TRICKED IT INTO THINKING ITS ARMS ARE *TASTY HUMANS!*

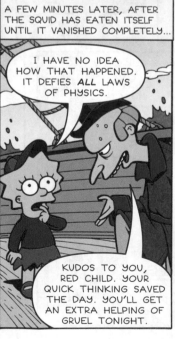

A FEW MINUTES LATER, AFTER THE SQUID HAS EATEN ITSELF UNTIL IT VANISHED COMPLETELY...

I HAVE NO IDEA HOW THAT HAPPENED. IT DEFIES *ALL* LAWS OF PHYSICS.

KUDOS TO YOU, RED CHILD. YOUR QUICK THINKING SAVED THE DAY. YOU'LL GET AN EXTRA HELPING OF GRUEL TONIGHT.

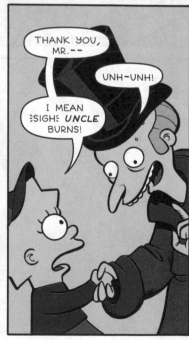

THANK YOU, MR.--

UNH-UNH!

I MEAN ⌐SIGH⌐ *UNCLE* BURNS!

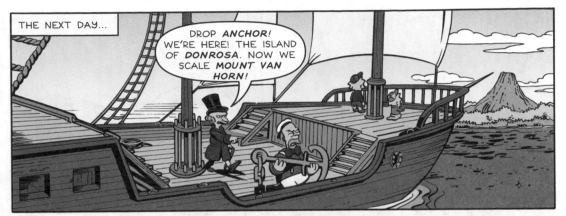

THE NEXT DAY...

DROP *ANCHOR!* WE'RE HERE! THE ISLAND OF *DONROSA.* NOW WE SCALE *MOUNT VAN HORN!*

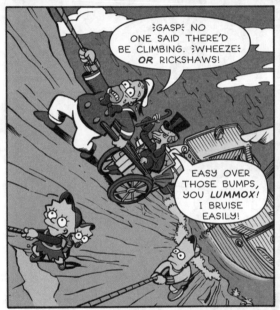

≡GASP≡ NO ONE SAID THERE'D BE CLIMBING. ≡WHEEZE≡ *OR* RICKSHAWS!

EASY OVER THOSE BUMPS, YOU *LUMMOX!* I BRUISE EASILY!

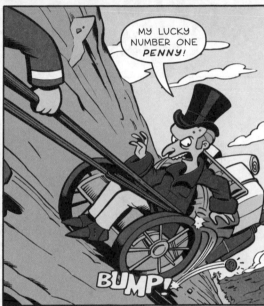

MY LUCKY NUMBER ONE *PENNY!*

BUMP!

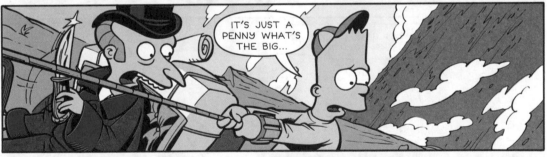

IT'S JUST A PENNY WHAT'S THE BIG...

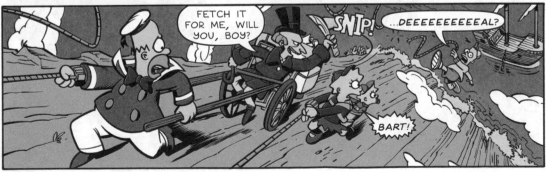

FETCH IT FOR ME, WILL YOU, BOY?

SNIP!

...DEEEEEEEEEAL?

BART!

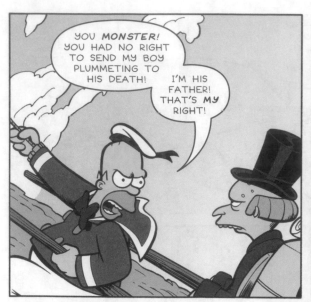

YOU *MONSTER!* YOU HAD NO RIGHT TO SEND MY BOY PLUMMETING TO HIS DEATH! I'M HIS FATHER! THAT'S *MY* RIGHT!

HUH?

CLAK! PFFFT.

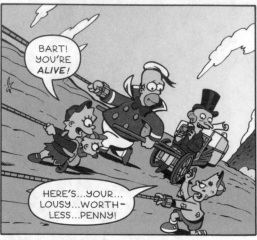

BART! YOU'RE *ALIVE!*

HERE'S...YOUR... LOUSY...WORTH-LESS...PENNY!

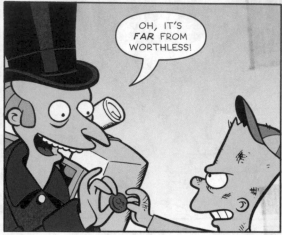

OH, IT'S *FAR* FROM WORTHLESS!

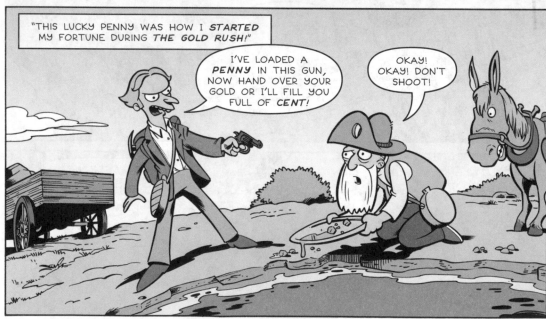

"THIS LUCKY PENNY WAS HOW I *STARTED* MY FORTUNE DURING *THE GOLD RUSH!*"

I'VE LOADED A *PENNY* IN THIS GUN, NOW HAND OVER YOUR GOLD OR I'LL FILL YOU FULL OF *CENT!*

OKAY! OKAY! DON'T SHOOT!

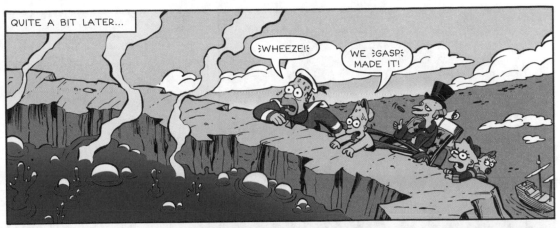

QUITE A BIT LATER...

:WHEEZE!:

WE :GASP: MADE IT!

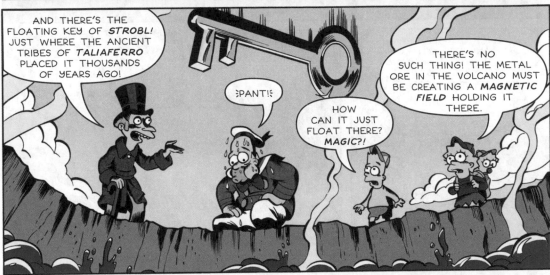

AND THERE'S THE FLOATING KEY OF *STROBL!* JUST WHERE THE ANCIENT TRIBES OF *TALIAFERRO* PLACED IT THOUSANDS OF YEARS AGO!

:PANT!:

HOW CAN IT JUST FLOAT THERE? *MAGIC?!*

THERE'S NO SUCH THING! THE METAL ORE IN THE VOLCANO MUST BE CREATING A *MAGNETIC FIELD* HOLDING IT THERE.

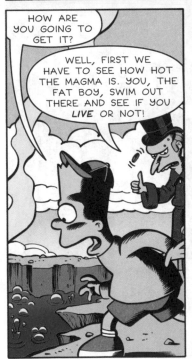

HOW ARE YOU GOING TO GET IT?

WELL, FIRST WE HAVE TO SEE HOW HOT THE MAGMA IS. YOU, THE FAT BOY, SWIM OUT THERE AND SEE IF YOU *LIVE* OR NOT!

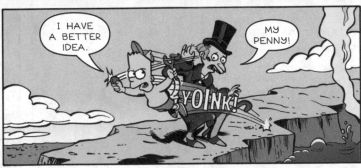

I HAVE A BETTER IDEA.

MY PENNY!

YOINK!

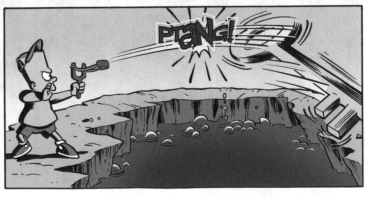

PTANG!

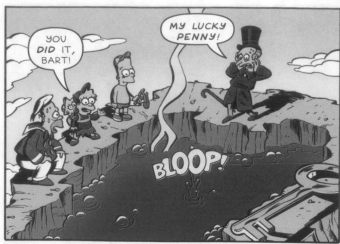

YOU *DID* IT, BART!

MY LUCKY PENNY!

BLOOP!

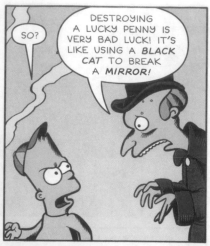

SO?

DESTROYING A LUCKY PENNY IS VERY BAD LUCK! IT'S LIKE USING A *BLACK CAT* TO BREAK A *MIRROR!*

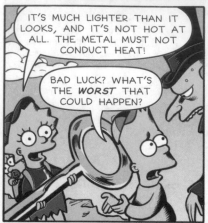

IT'S MUCH LIGHTER THAN IT LOOKS, AND IT'S NOT HOT AT ALL. THE METAL MUST NOT CONDUCT HEAT!

BAD LUCK? WHAT'S THE *WORST* THAT COULD HAPPEN?

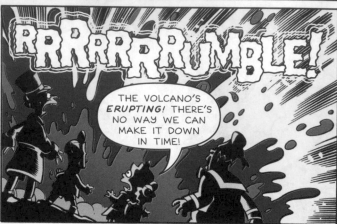

RRRRRRRUMBLE!

THE VOLCANO'S *ERUPTING!* THERE'S NO WAY WE CAN MAKE IT DOWN IN TIME!

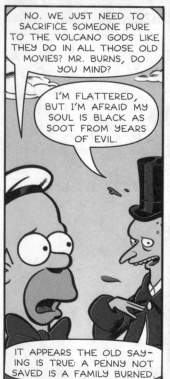

NO. WE JUST NEED TO SACRIFICE SOMEONE PURE TO THE VOLCANO GODS LIKE THEY DO IN ALL THOSE OLD MOVIES? MR. BURNS, DO YOU MIND?

I'M FLATTERED, BUT I'M AFRAID MY SOUL IS BLACK AS SOOT FROM YEARS OF EVIL.

IT APPEARS THE OLD SAYING IS TRUE: A PENNY NOT SAVED IS A FAMILY BURNED.

KIDS, I JUST WANT TO LET YOU KNOW, I LOVE YOU...

WE LOVE YOU TOO, DAD.

WOULD YOU LET ME FINISH A SENTENCE? SHEEESH!

I LOVE YOU KIDS MORE THAN TV. WELL, MORE THAN BASIC CABLE. AT LEAST WHEN IT'S NOT SWEEPS...

...OR DURING PLAYOFF SEASON OR...

A BIT LATER...

MAN, THAT HOT LAVA POURING INTO THE OCEAN STEAMED THESE FISH TO PERFECTION.

HOW'S YOUR STEAMED SEAWEED, LIS? AS GOOD AS IT LOOKS?

MMM... STINGRAY.

IT STINGS AS GOOD AS IT TASTES. OW! OW!

HRMMM...

SUCK! SUCK!

THE NEXT DAY...

THIS IS IT. WE'RE RIGHT OVER THE *GOTTFREDSON TRENCH*. ACCORDING TO THE MAP THE TREASURE SHOULD BE DIRECTLY BELOW US. SUIT UP!

OH, AND THERE'S A $5 DEPOSIT ON THE AIR TANKS.

WHAT?

NOT ALL OF YOU WILL BE *SURVIVING*, AND I HAVE TO RECOUP COSTS SOMEHOW.

WELL, WHEN YOU PUT IT *THAT* WAY...

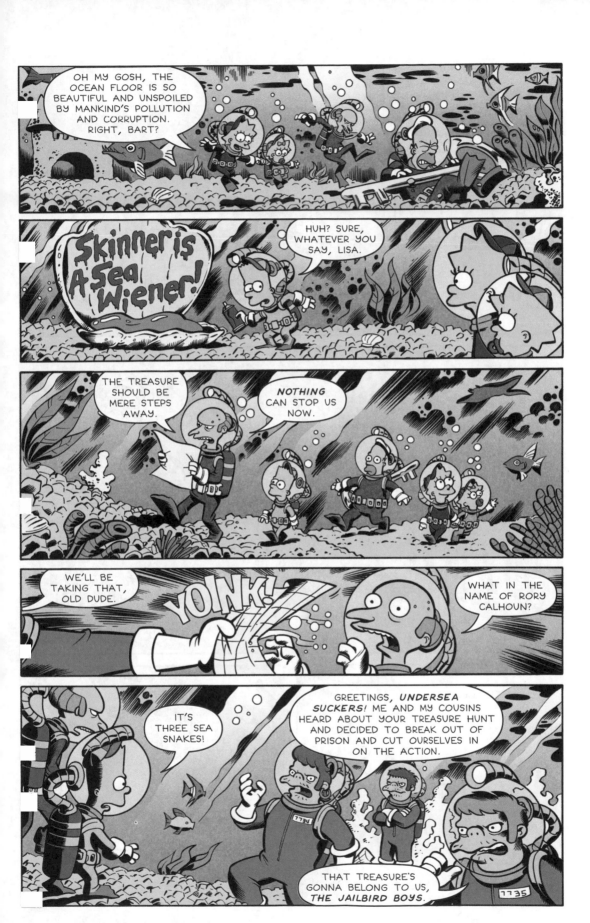

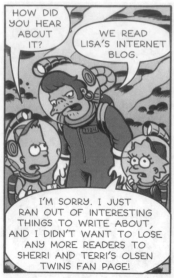

HOW DID YOU HEAR ABOUT IT?

WE READ LISA'S INTERNET BLOG.

I'M SORRY. I JUST RAN OUT OF INTERESTING THINGS TO WRITE ABOUT, AND I DIDN'T WANT TO LOSE ANY MORE READERS TO SHERRI AND TERRI'S OLSEN TWINS FAN PAGE!

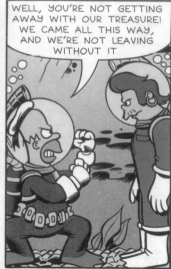

WELL, YOU'RE NOT GETTING AWAY WITH OUR TREASURE! WE CAME ALL THIS WAY, AND WE'RE NOT LEAVING WITHOUT IT.

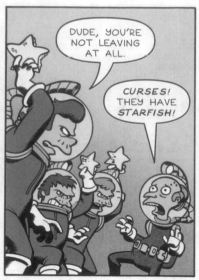

DUDE, YOU'RE NOT LEAVING AT ALL.

CURSES! THEY HAVE STARFISH!

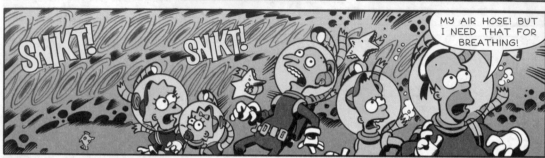

SNIKT!

SNIKT!

MY AIR HOSE! BUT I NEED THAT FOR BREATHING!

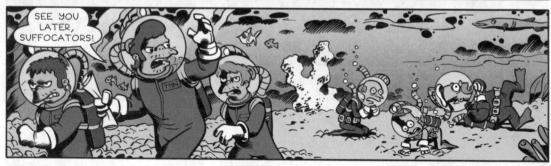

SEE YOU LATER, SUFFOCATORS!

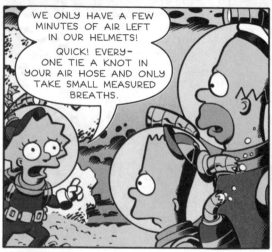

WE ONLY HAVE A FEW MINUTES OF AIR LEFT IN OUR HELMETS!

QUICK! EVERY- ONE TIE A KNOT IN YOUR AIR HOSE AND ONLY TAKE SMALL MEASURED BREATHS.

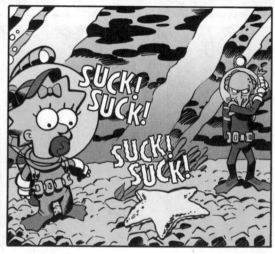

SUCK! SUCK!

SUCK! SUCK!

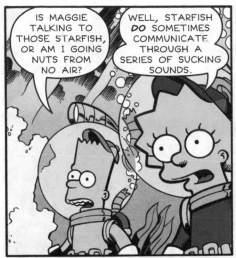

IS MAGGIE TALKING TO THOSE STARFISH, OR AM I GOING NUTS FROM NO AIR?

WELL, STARFISH *DO* SOMETIMES COMMUNICATE THROUGH A SERIES OF SUCKING SOUNDS.

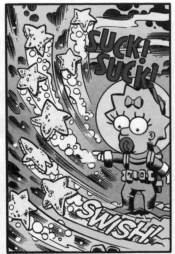

SUCK! SUCK!

SWISH!

LIKE... WHAT--?!

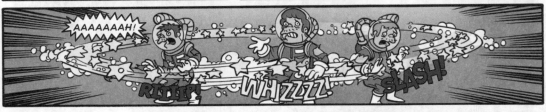

AAAAAAAH!

RIP!! WHIZZZZ. SLASH!

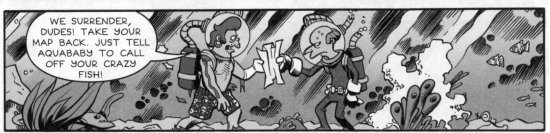

WE SURRENDER, DUDES! TAKE YOUR MAP BACK. JUST TELL AQUABABY TO CALL OFF YOUR CRAZY FISH!

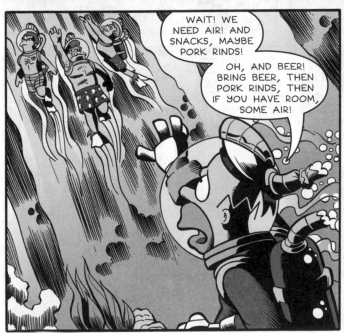

WAIT! WE NEED AIR! AND SNACKS, MAYBE PORK RINDS!

OH, AND BEER! BRING BEER, THEN PORK RINDS, THEN IF YOU HAVE ROOM, SOME AIR!

WHAM!

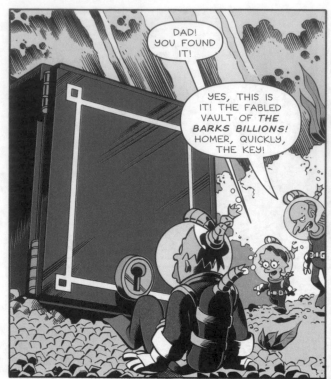

DAD! YOU FOUND IT!

YES, THIS IS IT! THE FABLED VAULT OF *THE BARKS BILLIONS!* HOMER, QUICKLY, THE KEY!

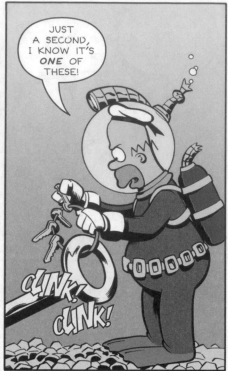

JUST A SECOND, I KNOW IT'S *ONE* OF THESE!

CLINK! CLINK!

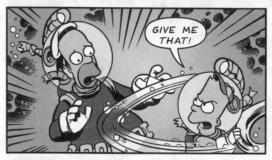

GIVE ME THAT!

SWIIISH!

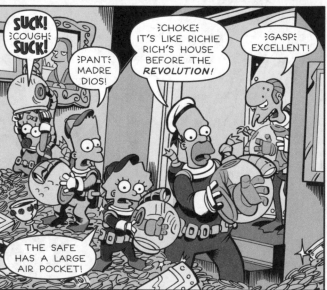

SUCK! COUGH SUCK!

:PANT: MADRE DIOS!

:CHOKE: IT'S LIKE RICHIE RICH'S HOUSE BEFORE THE *REVOLUTION!*

:GASP: EXCELLENT!

THE SAFE HAS A LARGE AIR POCKET!

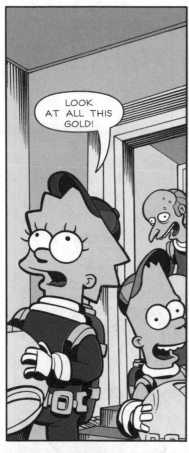

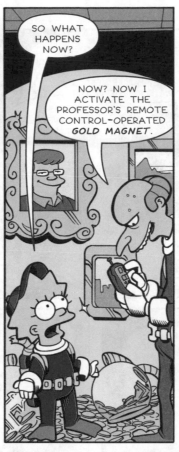

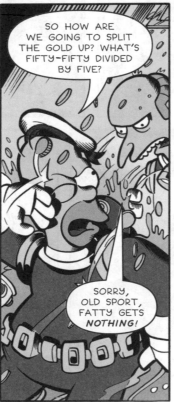

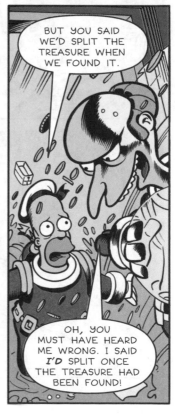

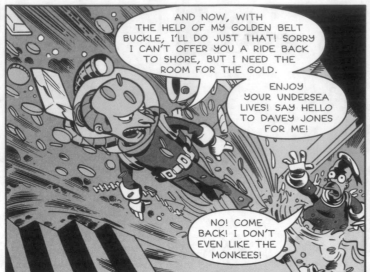

AND NOW, WITH THE HELP OF MY GOLDEN BELT BUCKLE, I'LL DO JUST THAT! SORRY I CAN'T OFFER YOU A RIDE BACK TO SHORE, BUT I NEED THE ROOM FOR THE GOLD.

ENJOY YOUR UNDERSEA LIVES! SAY HELLO TO DAVEY JONES FOR ME!

NO! COME BACK! I DON'T EVEN LIKE THE MONKEES!

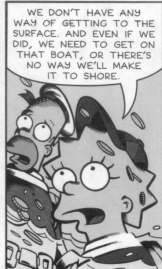

WE DON'T HAVE ANY WAY OF GETTING TO THE SURFACE. AND EVEN IF WE DID, WE NEED TO GET ON THAT BOAT, OR THERE'S NO WAY WE'LL MAKE IT TO SHORE.

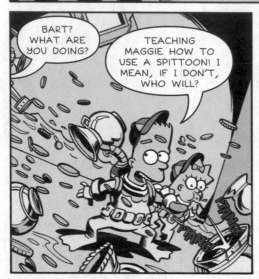

BART? WHAT ARE YOU DOING?

TEACHING MAGGIE HOW TO USE A SPITTOON! I MEAN, IF I DON'T, WHO WILL?

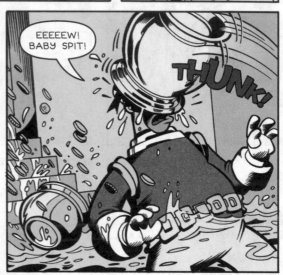

EEEEEW! BABY SPIT!

THUNK!

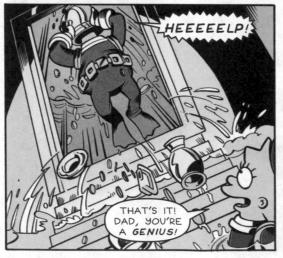

HEEEEELP!

THAT'S IT! DAD, YOU'RE A GENIUS!

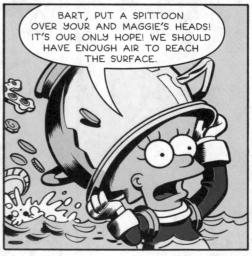

BART, PUT A SPITTOON OVER YOUR AND MAGGIE'S HEADS! IT'S OUR ONLY HOPE! WE SHOULD HAVE ENOUGH AIR TO REACH THE SURFACE.

I DON'T KNOW WHY PEOPLE SAY FISHING IS BORING, MY HEART'S GOING THREE BEATS A MINUTE!

CLICK!

WHAT? I DON'T REMEMBER SEEING ANY STATUES IN THE VAULT, AND WHY MAKE THEM SO OUT OF SHAPE?

YOU'RE ALIVE?

OOOF!

OW!

GAH!

THUD!

THUD!

THUD!

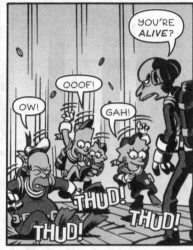

I MEAN...HUZZAH! YOU'RE ALIVE! MY RESCUE PLAN FOR YOU WORKED PERFECTLY! I HOPE YOU DIDN'T TAKE MY PRACTICAL AMUSEMENT JOKE ABOUT ABANDONING YOU THE WRONG WAY!

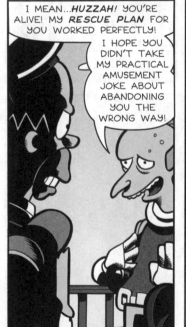

MR. BURNS! ONCE WE REACH SHORE WE'RE GOING TO THE POLICE!

THERE'S NO NEED TO BRING THE CONSTABULARIES INTO THIS. WHAT SAY, ONCE WE REACH SHORE, I PRESENT YOU ALL WITH YOUR WEIGHT IN GOLD?

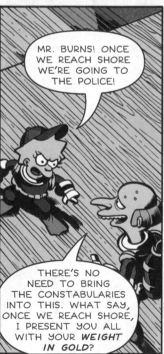

WHAT DO I SAY? WOO-HOO!

THE NEXT DAY...

"WELL EVERYONE, STEP ON THE SCALE, AND WE'LL GET YOU YOUR GOLD!"

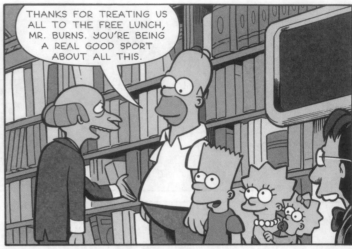

THANKS FOR TREATING US ALL TO THE FREE LUNCH, MR. BURNS. YOU'RE BEING A REAL GOOD SPORT ABOUT ALL THIS.

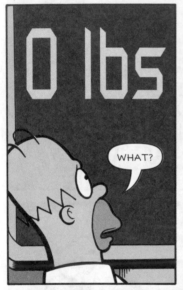

0 lbs

WHAT?

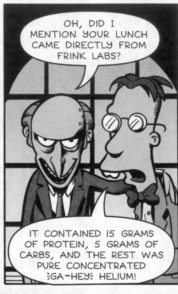

OH, DID I MENTION YOUR LUNCH CAME DIRECTLY FROM FRINK LABS?

IT CONTAINED 15 GRAMS OF PROTEIN, 5 GRAMS OF CARBS, AND THE REST WAS PURE CONCENTRATED 〔GA-HEY〕 HELIUM!

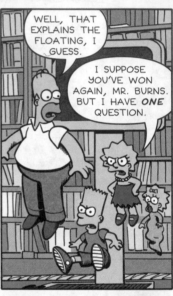

WELL, THAT EXPLAINS THE FLOATING, I GUESS.

I SUPPOSE YOU'VE WON AGAIN, MR. BURNS. BUT I HAVE **ONE** QUESTION.

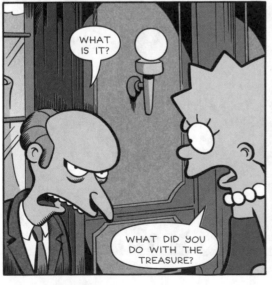

WHAT IS IT?

WHAT DID YOU DO WITH THE TREASURE?

CLICK!

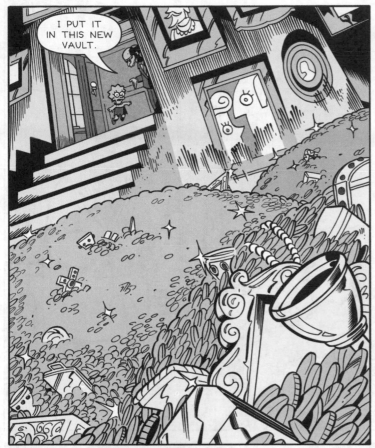

I PUT IT IN THIS NEW VAULT.

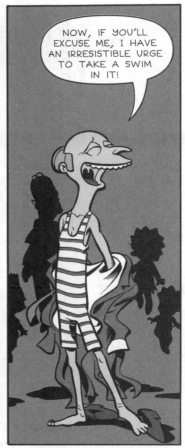

NOW, IF YOU'LL EXCUSE ME, I HAVE AN IRRESISTIBLE URGE TO TAKE A SWIM IN IT!

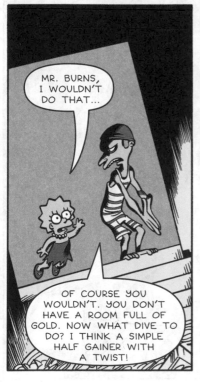

MR. BURNS, I WOULDN'T DO THAT...

OF COURSE YOU WOULDN'T. YOU DON'T HAVE A ROOM FULL OF GOLD. NOW WHAT DIVE TO DO? I THINK A SIMPLE HALF GAINER WITH A TWIST!

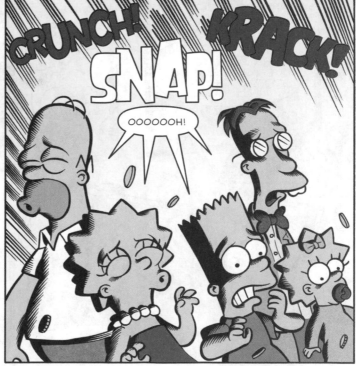

CRUNCH!
KRACK!
SNAP!
OOOOOOH!

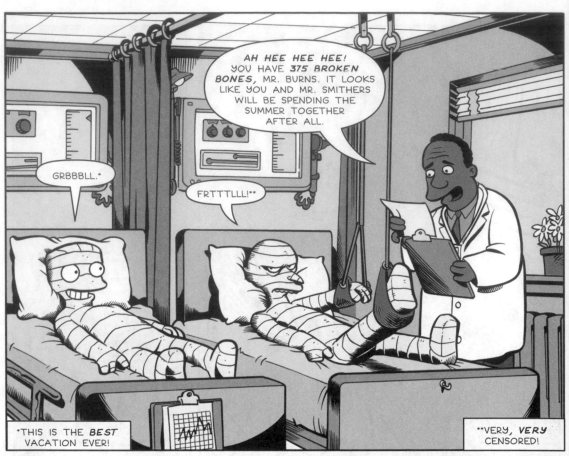

THE END!

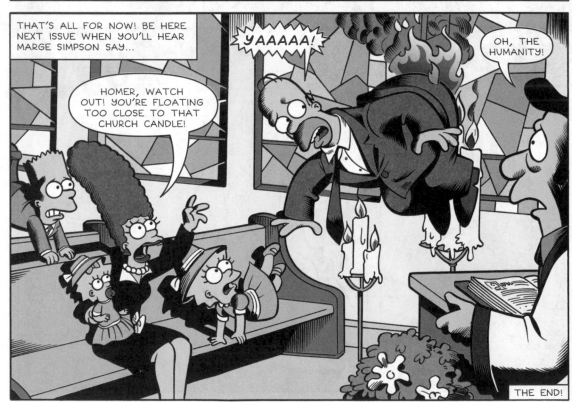

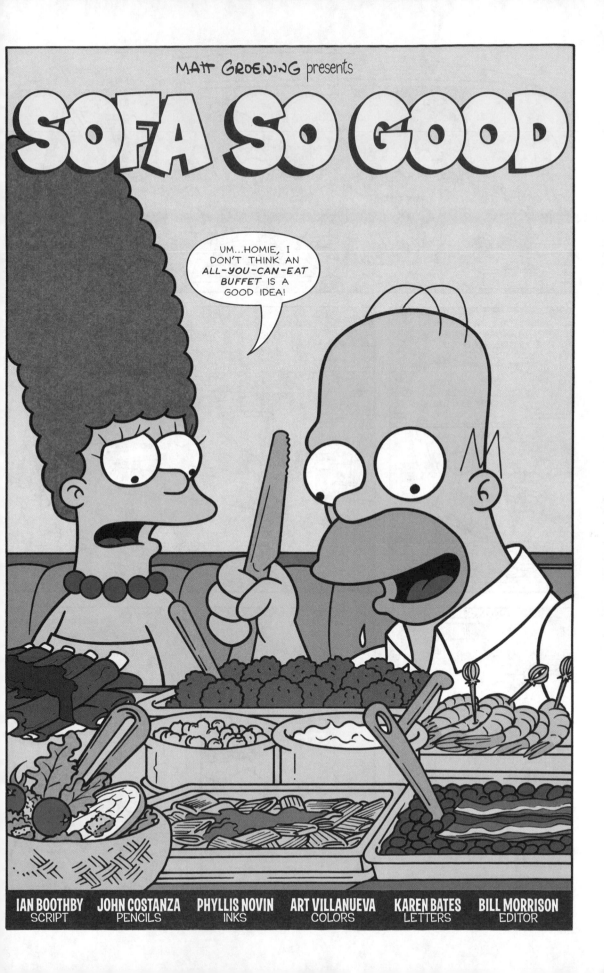

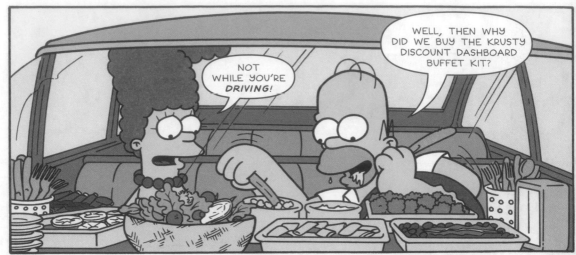

NOT WHILE YOU'RE *DRIVING*!

WELL, THEN WHY DID WE BUY THE KRUSTY DISCOUNT DASHBOARD BUFFET KIT?

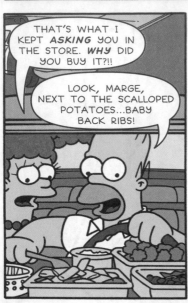

THAT'S WHAT I KEPT *ASKING* YOU IN THE STORE. *WHY* DID YOU BUY IT?!!

LOOK, MARGE, NEXT TO THE SCALLOPED POTATOES...BABY BACK RIBS!

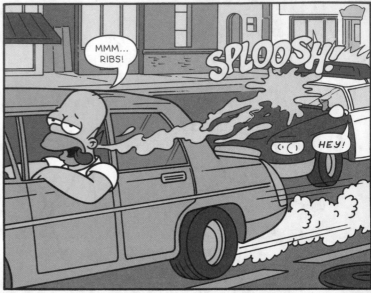

MMM... RIBS!

SPLOOSH!

HEY!

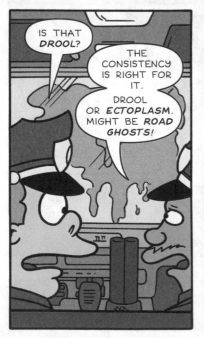

IS THAT *DROOL*?

THE CONSISTENCY IS RIGHT FOR IT. DROOL OR *ECTOPLASM*. MIGHT BE *ROAD GHOSTS*!

R-R-ROAD G-G-GHOSTS?

NOW WHAT DID I TELL YOU ABOUT SCARING EDDIE LIKE THAT?

WHOOOO! WHOOO!

PULL OVER, *SALIVA-TOR DALI*!

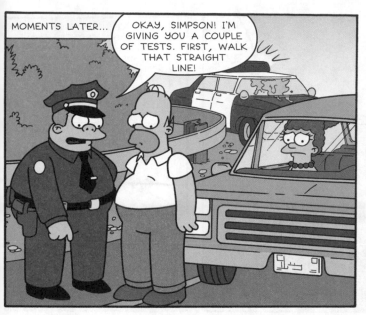

MOMENTS LATER...

OKAY, SIMPSON! I'M GIVING YOU A COUPLE OF TESTS. FIRST, WALK THAT STRAIGHT LINE!

UM...*WHAT* STRAIGHT LINE?

NOW BRING YOUR FINGERS TOGETHER IN FRONT OF YOUR STOMACH!

GRRR! LOUSY FINGERS! WHY WON'T YOU TOUCH EACH OTHER?!

NOW BREATHE INTO THIS TUBE!

HE'S GOT A *BACON-FAT LEVEL* OF 15%, CHIEF!

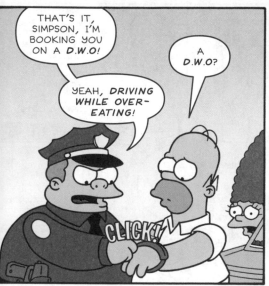

THAT'S IT, SIMPSON, I'M BOOKING YOU ON A *D.W.O!*

A *D.W.O?*

YEAH, *DRIVING WHILE OVER-EATING!*

CLICK!

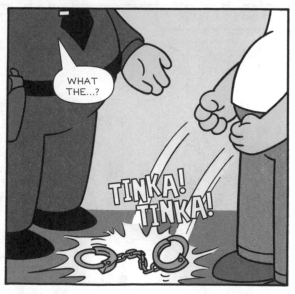

WHAT THE...?

TINKA! TINKA!

33

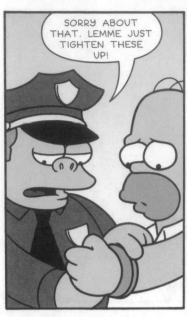

SORRY ABOUT THAT. LEMME JUST TIGHTEN THESE UP!

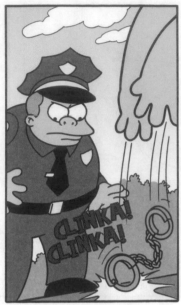

CLINKA! CLINKA!

BUT THAT'S THE TIGHTEST SETTING. WE USED THAT ONE THE TIME WE HAD TO ARREST MAGGIE!

I DON'T UNDERSTAND.

LATER...

AH HEE HEE HEE! WELL, IT'S QUITE SIMPLE, HOMER.

WHAT IS IT, DOCTOR HIBBERT? AM I LOSING WEIGHT? SHOULD I EAT MORE? MARGE KEEPS TELLING ME NOT TO MIX FROSTING AND GRAVY, BUT IF I HAVE TO...

QUITE THE OPPOSITE. ALL YOUR YEARS OF EATING GREASY FOOD HAVE GIVEN YOU A THIN LAYER OF OIL ON YOUR SKIN THAT WON'T WASH OFF.

I'LL SHOW YOU WHAT I MEAN.

ONE MINUTE LATER...

UH, DOC...I'M NOT REALLY THAT COMFORTABLE WITH THIS...

THEN STAND UP, HOMER!

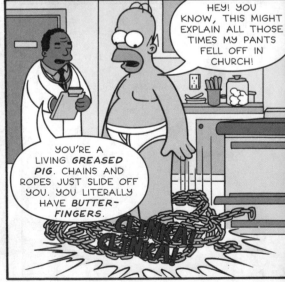

HEY! YOU KNOW, THIS MIGHT EXPLAIN ALL THOSE TIMES MY PANTS FELL OFF IN CHURCH!

YOU'RE A LIVING GREASED PIG. CHAINS AND ROPES JUST SLIDE OFF YOU. YOU LITERALLY HAVE BUTTER-FINGERS.

CLINKA! CLINKA!

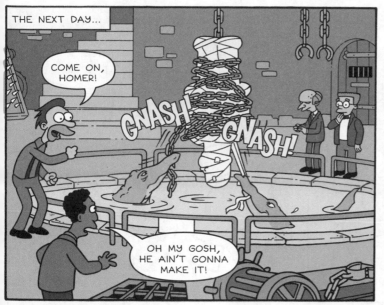

THE NEXT DAY...

COME ON, HOMER!

GNASH! GNASH!

OH MY GOSH, HE AIN'T GONNA MAKE IT!

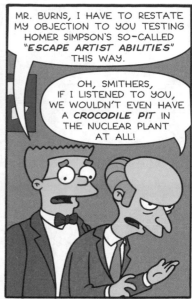

MR. BURNS, I HAVE TO RESTATE MY OBJECTION TO YOU TESTING HOMER SIMPSON'S SO-CALLED *"ESCAPE ARTIST ABILITIES"* THIS WAY.

OH, SMITHERS, IF I LISTENED TO YOU, WE WOULDN'T EVEN HAVE A *CROCODILE PIT* IN THE NUCLEAR PLANT AT ALL!

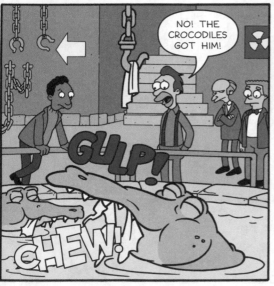

NO! THE CROCODILES GOT HIM!

GULP!

CHEW!

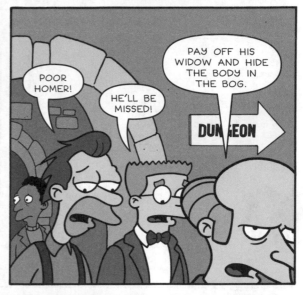

POOR HOMER!

HE'LL BE MISSED!

PAY OFF HIS WIDOW AND HIDE THE BODY IN THE BOG.

DUNGEON

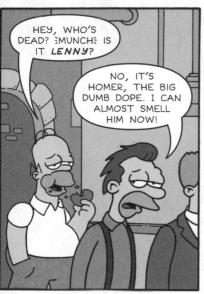

HEY, WHO'S DEAD? [MUNCH] IS IT *LENNY*?

NO, IT'S HOMER, THE BIG DUMB DOPE. I CAN ALMOST SMELL HIM NOW!

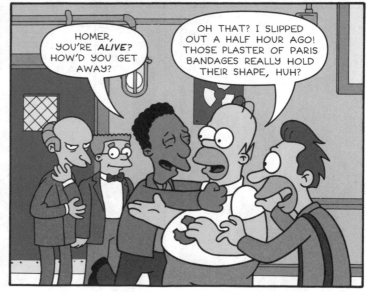

HOMER, YOU'RE *ALIVE*? HOW'D YOU GET AWAY?

OH THAT? I SLIPPED OUT A HALF HOUR AGO! THOSE PLASTER OF PARIS BANDAGES REALLY HOLD THEIR SHAPE, HUH?

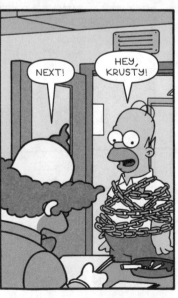

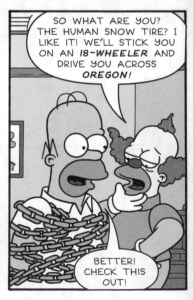

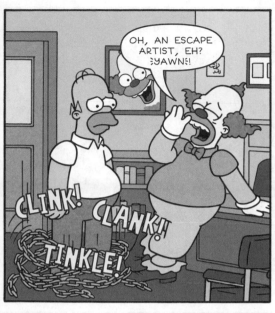

OH, AN ESCAPE ARTIST, EH? ⟨YAWN⟩!

CLINK! CLANK! TINKLE!

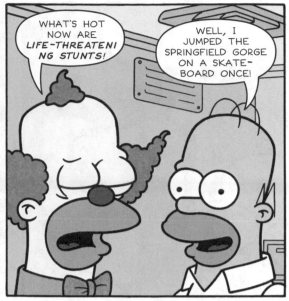

WHAT'S HOT NOW ARE *LIFE-THREATENING STUNTS*!

WELL, I JUMPED THE SPRINGFIELD GORGE ON A SKATE-BOARD ONCE!

BIG DEAL. I HOSTED A SHRINERS JUMP-A-THON LAST MONTH!

I'M SORRY. WE JUST DON'T NEED--

WAIT, YOU WANT *DANGER*? I'LL *GIVE* YOU DANGER!

AND SO...

LET'S KEEP THE APPLAUSE GOING FOR GIL AND HIS AMAZING *FLAMING HOOP-JUMPING DOLPHIN*!

HIS LOSS IS THE SUSHI RESTAURANT NEXT DOOR'S GAIN!

CLAP! CLAP! CLAP! CLAP! CLAP!

AND NOW...BEHOLD AN ACT SO DANGEROUS I HESITATE TO EVEN PUT IT ON THE AIR!

HOMER SIMPSON IS BOUND IN THE THICKEST CHAINS AVAILABLE FROM KRUSTY'S DISCOUNT DUNGEON DEPOT!

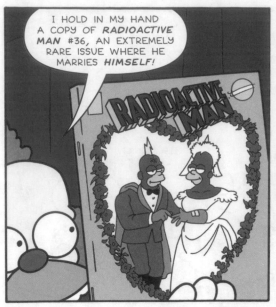

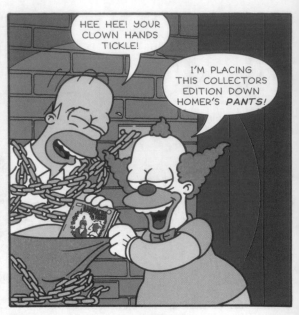

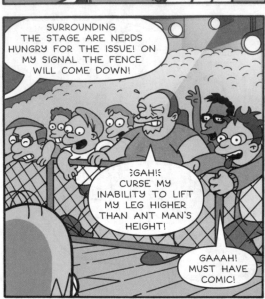

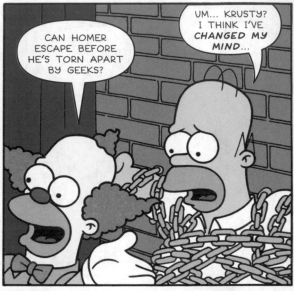

THE ISSUE IS *MINE!*

BUT WHERE'S HOMER? IS THERE *NOTHING* LEFT?

NOTHING LEFT ON THE *CRAFT SERVICES TABLE,* PERHAPS!

:GORGE:

LADIES AND GENTLEMEN TUNE IN NEXT WEEK FOR ANOTHER DARING ESCAPE FOR *"THE AMAZING LARDINI!"*

:MUNCH: CAN'T BASK IN ADMIRATION! :GULP: EATING!

WOW! DAD'S *FAMOUS!*

:SIGH!: YES! *AGAIN!*

WHAT'S WITH YOU?

DAD'S FAMOUS! AND WHY? BECAUSE HE DID NOTHING! HE ATE UNTIL HE WAS GREASY!

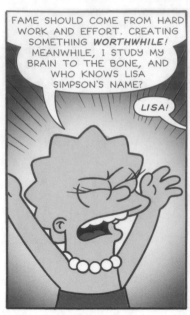

FAME SHOULD COME FROM HARD WORK AND EFFORT. CREATING SOMETHING *WORTHWHILE!* MEANWHILE, I STUDY MY BRAIN TO THE BONE, AND WHO KNOWS LISA SIMPSON'S NAME?

LISA!

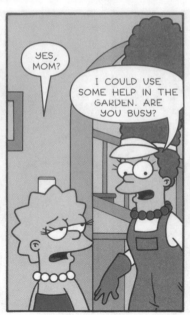

YES, MOM?

I COULD USE SOME HELP IN THE GARDEN. ARE YOU BUSY?

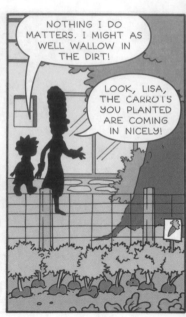

NOTHING I DO MATTERS. I MIGHT AS WELL WALLOW IN THE DIRT!

LOOK, LISA, THE CARROTS YOU PLANTED ARE COMING IN NICELY!

AND WITH THE COST OF SEEDS, PLANT FOOD, AND GARDENING TOOLS, THEY'RE ONLY TWICE AS EXPENSIVE AS IF WE BOUGHT THEM IN THE STORE.

HEY, WHAT ARE THESE?

HENDERSON ROSES. THEY'RE A CROSS BETWEEN A WHITE AND RED ROSE. AREN'T THEY PRETTY?

WHY ARE THEY CALLED *"HENDERSON"*?

THAT'S THE NAME OF THE PERSON WHO *CREATED* THEM.

THAT'S IT!

WHAT'S WHAT?

MY WAY OF GETTING MY NAME KNOWN! I'LL CREATE A NEW TYPE OF PLANT AND NAME IT AFTER MYSELF! THAT'LL SHOW DAD THE RIGHT WAY TO MAKE A NAME FOR YOURSELF! *HARD WORK* AND *EFFORT!*

A WEEK LATER...

IT'S BEEN *TWENTY MINUTES* SINCE WE LOCKED HOMER IN A FULL KEG OF BEER!

IS THERE ANY WAY HE CAN STILL BE ALIVE? OR IS THIS DUFF BEER CANISTER TO BECOME HIS FROTHY, DELICIOUS *TOMB*?

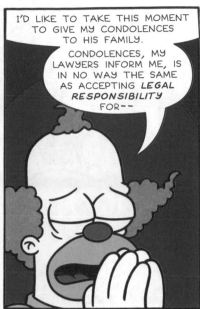

I'D LIKE TO TAKE THIS MOMENT TO GIVE MY CONDOLENCES TO HIS FAMILY.

CONDOLENCES, MY LAWYERS INFORM ME, IS IN NO WAY THE SAME AS ACCEPTING *LEGAL RESPONSIBILITY* FOR--

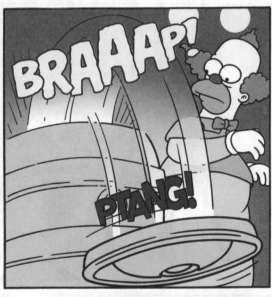

BRAAAP!

PTANG!

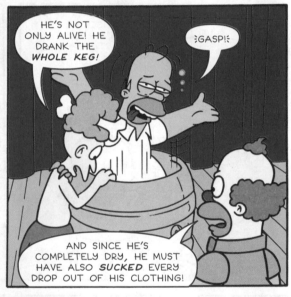

HE'S NOT ONLY ALIVE! HE DRANK THE *WHOLE KEG*!

⸰GASP!⸰

AND SINCE HE'S COMPLETELY DRY, HE MUST HAVE ALSO *SUCKED* EVERY DROP OUT OF HIS CLOTHING!

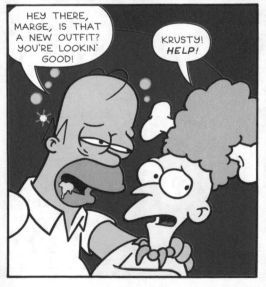

HEY THERE, MARGE, IS THAT A NEW OUTFIT? YOU'RE LOOKIN' GOOD!

KRUSTY! *HELP!*

SO, FOLKS, WHAT DO YOU THINK OF HOMER'S NEAR DEATH, OR SHOULD I SAY, *BEER DEATH* ESCAPE?

SMATTER!

CLAP!

WHAT DO YOU MEAN "I'M NOT BACK NEXT WEEK?" I'M THE GREAT LARDINI!

THAT REMINDS ME. A PASTA COMPANY IN SEATTLE IS SUING US OVER THE NAME. TURNS OUT *LARDINI* IS THEIR LOW-CARB PASTA MADE WITH *HOG FAT!*

Lard

SORRY, HOMER, BUT DANGEROUS STUNTS ARE *OUT!*

CHECK OUT THESE CLIPS ON THE INTERNET!

CRUNCH!
CRUNCH!

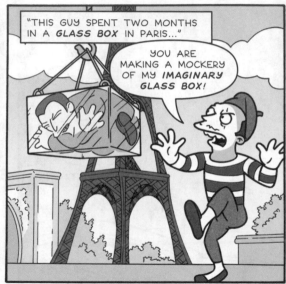

"THIS GUY SPENT TWO MONTHS IN A *GLASS BOX* IN PARIS..."

YOU ARE MAKING A MOCKERY OF MY *IMAGINARY GLASS BOX!*

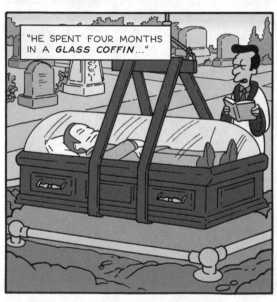

"HE SPENT FOUR MONTHS IN A *GLASS COFFIN*..."

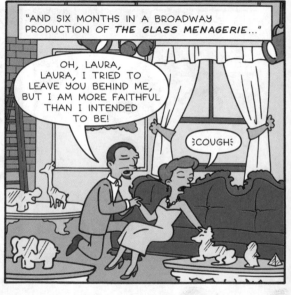

"AND SIX MONTHS IN A BROADWAY PRODUCTION OF *THE GLASS MENAGERIE*..."

OH, LAURA, LAURA, I TRIED TO LEAVE YOU BEHIND ME, BUT I AM MORE FAITHFUL THAN I INTENDED TO BE!

:COUGH:

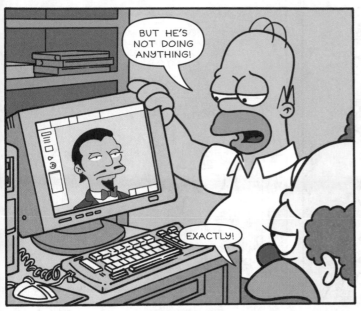

BUT HE'S NOT DOING ANYTHING!

EXACTLY!

YOUR SOMETHING IS NOTHING!

BUT HIS *NOTHING*, MAN, THAT'S *SOMETHING!*

BUT I WAS *FAMOUS!* I CAN'T GO BACK TO JUST BEING A *NOBODY!*

I KNOW WHAT YOU MEAN, PAL. *FAME* IS THE MOST ADDICTIVE *DRUG* THERE IS.

WHICH *REMINDS* ME, IT'S TIME FOR MY *PERCODAN!*

FINE, I KNOW WHEN I'M NOT *WANTED!*

LET'S GO HOME, MARGE!

KRUSTY!

JUST ⦊GLUG⦉ BE BACK FOR ⦊CHOMP⦉ DRESS REHEARSAL, MEL!

MEANWHILE...

COME ON, APPLE AND ASPARAGUS, *CROSS POLLINATE!*

43

WHATCHA DOING, LIS?

I'M TRYING TO MAKE A NEW FRUIT OR VEGETABLE.

WHAT? YOU'RE ACTUALLY TRYING TO MAKE *NEW* HEALTHY FOOD FOR PARENTS TO FORCE US KIDS TO EAT?

IT'S MONSTERS LIKE YOU THAT CREATED *BROCCOLI!*

SNOWBALL II, NO! THAT'S *NOT* A *LITTER BOX!*

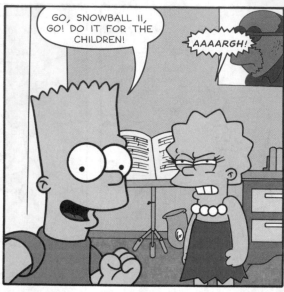

GO, SNOWBALL II, GO! DO IT FOR THE CHILDREN!

AAAARGH!

LATER THAT AFTERNOON...

DING DONG!

SEYMOUR! THE DOOR BELL'S RINGING!

I *KNOW,* MOTHER!

44

WHO IS IT?

A *LITTLE GIRL*, MOTHER!

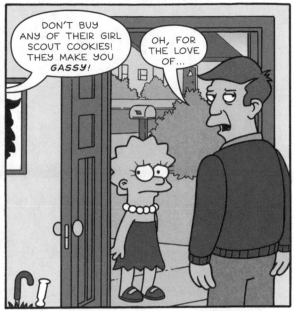

DON'T BUY ANY OF THEIR GIRL SCOUT COOKIES! THEY MAKE YOU *GASSY*!

OH, FOR THE LOVE OF...

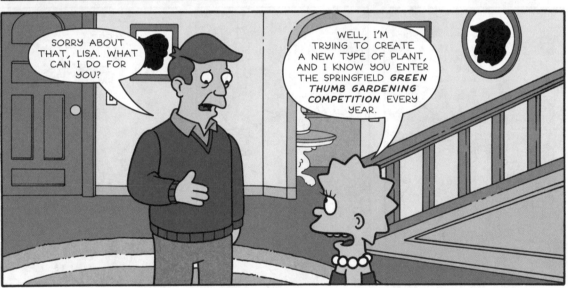

SORRY ABOUT THAT, LISA. WHAT CAN I DO FOR YOU?

WELL, I'M TRYING TO CREATE A NEW TYPE OF PLANT, AND I KNOW YOU ENTER THE SPRINGFIELD *GREEN THUMB GARDENING COMPETITION* EVERY YEAR.

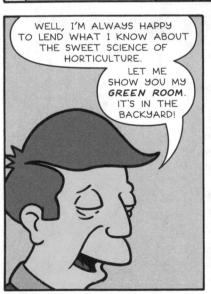

WELL, I'M ALWAYS HAPPY TO LEND WHAT I KNOW ABOUT THE SWEET SCIENCE OF HORTICULTURE.

LET ME SHOW YOU MY *GREEN ROOM*. IT'S IN THE BACKYARD!

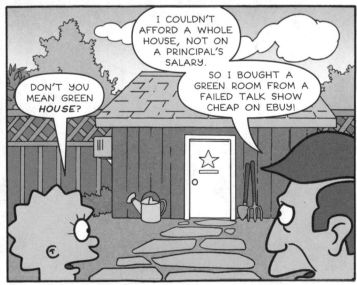

DON'T YOU MEAN GREEN *HOUSE*?

I COULDN'T AFFORD A WHOLE HOUSE, NOT ON A PRINCIPAL'S SALARY.

SO I BOUGHT A GREEN ROOM FROM A FAILED TALK SHOW CHEAP ON EBUY!

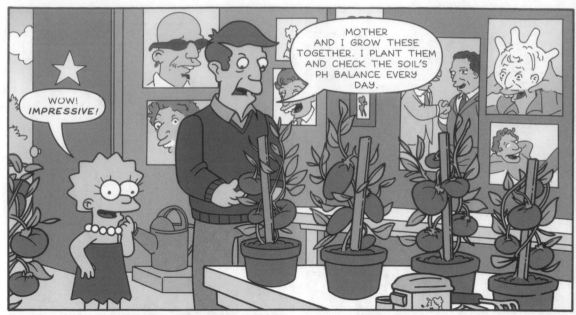

WOW! *IMPRESSIVE!*

MOTHER AND *I* GROW THESE TOGETHER. I PLANT THEM AND CHECK THE SOIL'S PH BALANCE EVERY DAY.

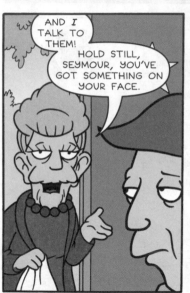

AND *I* TALK TO THEM!

HOLD STILL, SEYMOUR, YOU'VE GOT SOMETHING ON YOUR FACE.

PTUIII!

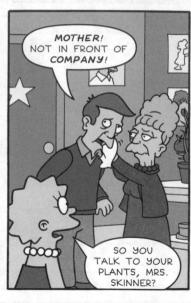

MOTHER! NOT IN FRONT OF *COMPANY!*

SO YOU TALK TO YOUR PLANTS, MRS. SKINNER?

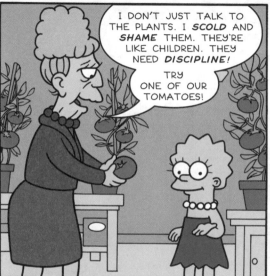

I DON'T JUST TALK TO THE PLANTS. I *SCOLD* AND *SHAME* THEM. THEY'RE LIKE CHILDREN. THEY NEED *DISCIPLINE!*

TRY ONE OF OUR TOMATOES!

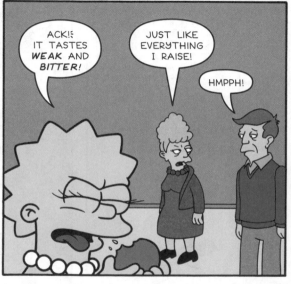

ACK!‽ IT TASTES *WEAK* AND *BITTER!*

JUST LIKE EVERYTHING I RAISE!

HMPPH!

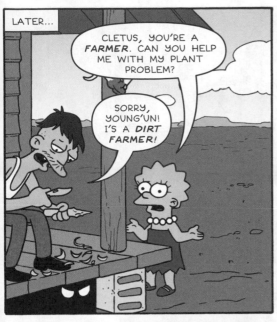

LATER...

CLETUS, YOU'RE A *FARMER*. CAN YOU HELP ME WITH MY PLANT PROBLEM?

SORRY, YOUNG'UN! I'S A *DIRT FARMER*!

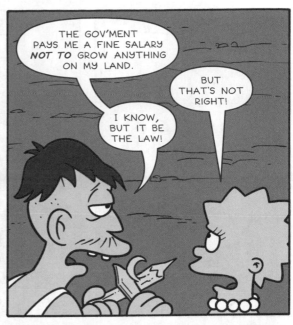

THE GOV'MENT PAYS ME A FINE SALARY *NOT TO* GROW ANYTHING ON MY LAND.

I KNOW, BUT IT BE THE LAW!

BUT THAT'S NOT RIGHT!

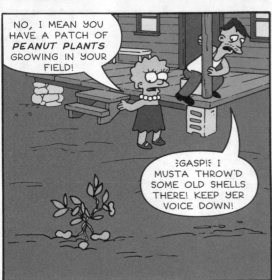

NO, I MEAN YOU HAVE A PATCH OF *PEANUT PLANTS* GROWING IN YOUR FIELD!

⟨GASP!⟩ I MUSTA THROW'D SOME OLD SHELLS THERE! KEEP YER VOICE DOWN!

SKREEEEE!

SKREEEEE!

SO, GROWING FOOD ON FARM LAND ARE WE?

WE'LL BE TAKING OUR MONEY BACK NOW!

I IS *DESTITUTE*!

BRANDINE, WE NEED TO *DOWNSIZE* THE YOUNG'UNS AGAIN!

⟨SIGH!⟩

MEANWHILE...

OH, DON'T BE SO GLUM, HOMER!

NO ONE WANTS TO SEE MY ESCAPES, MARGE!

FOR THE LAST TIME, I'M *NOT* MARGE!

NOW LET GO OF MY HAND!

SLAM!

I THOUGHT HE'D *NEVER* LEAVE.

THERE'S NO USE DWELLING ON THINGS, HOMIE! THERE'S NOTHING YOU CAN DO!

NOTHING I CAN DO?

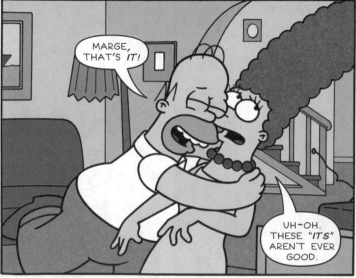

MARGE, THAT'S *IT!*

UH-OH. THESE *"ITS"* AREN'T EVER GOOD.

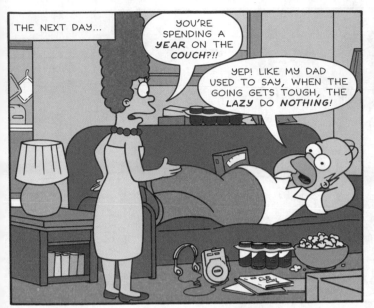

THE NEXT DAY...

YOU'RE SPENDING A *YEAR* ON THE *COUCH?!!*

YEP! LIKE MY DAD USED TO SAY, WHEN THE GOING GETS TOUGH, THE *LAZY* DO *NOTHING!*

HOMER, THIS IS *SILLY*, NO ONE IS INTERESTED IN...

DING! DONG!

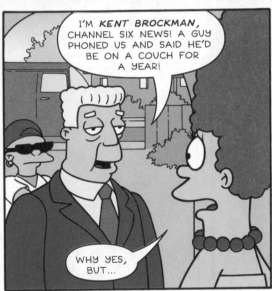

I'M *KENT BROCKMAN*, CHANNEL SIX NEWS! A GUY PHONED US AND SAID HE'D BE ON A COUCH FOR A YEAR!

WHY YES, BUT...

SHE SAID *YES*. COME ON IN, STEVE!

WE'LL *EMBED* OURSELVES IN THE LIVING ROOM!

BUT WHY ARE YOU INTERESTED?

WELL, IT'S THIS OR COVER REAL NEWS, AND THAT'S HARD AND SOMETIMES DANGEROUS.

NOW, WHAT'S FOR DINNER?

LISA, WHY DIDN'T YOU JUST COME TO ME IN THE *FIRST PLACE*? *EGA-HAVEN!* I STARTED MY SCIENTIFIC CAREER AS A GENETIC SCIENTIST *BREEDING PLANTS*!

DID YOU EVER HAVE ANYTHING NAMED AFTER YOU?

WHY, YES. I INVENTED THE *FREEZE-DRIED FRINKLEBERRIES* FOUND IN EVERY BOX OF *CAPTAIN MCCALLISTER'S FRINKLEBERRY CEREAL*!

NEW! *Captain McCallister's* FRINKLEBERRY CEREAL

WARNING: BERRIES MAY CUT GUMS, TONGUE AND THE ROOF OF THE MOUTH

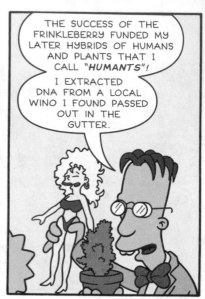

THE SUCCESS OF THE FRINKLEBERRY FUNDED MY LATER HYBRIDS OF HUMANS AND PLANTS THAT I CALL "*HUMANTS*"!

I EXTRACTED DNA FROM A LOCAL WINO I FOUND PASSED OUT IN THE GUTTER.

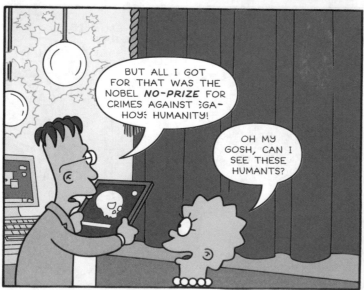

BUT ALL I GOT FOR THAT WAS THE NOBEL *NO-PRIZE* FOR CRIMES AGAINST *EGA-HOY* HUMANITY!

OH MY GOSH, CAN I SEE THESE HUMANTS?

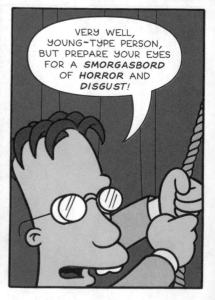

VERY WELL, YOUNG-TYPE PERSON, BUT PREPARE YOUR EYES FOR A *SMORGASBORD* OF *HORROR* AND *DISGUST*!

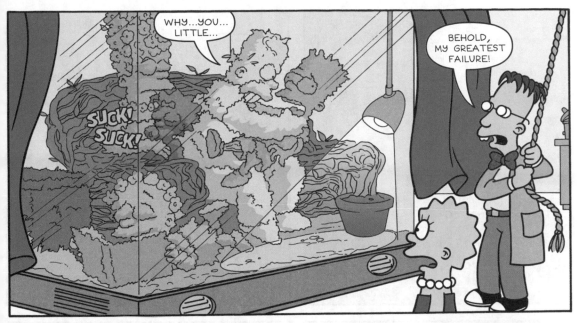

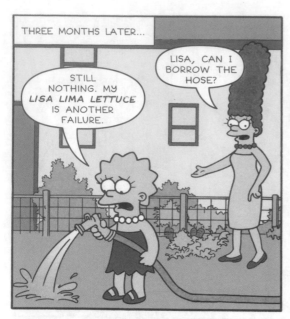

THREE MONTHS LATER...

STILL NOTHING. MY *LISA LIMA LETTUCE* IS ANOTHER FAILURE.

LISA, CAN I BORROW THE HOSE?

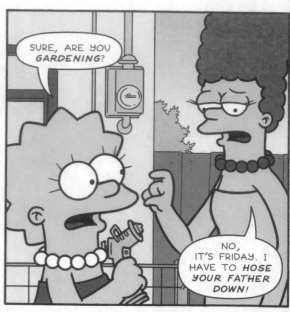

SURE, ARE YOU *GARDENING*?

NO, IT'S FRIDAY. I HAVE TO *HOSE YOUR FATHER DOWN*!

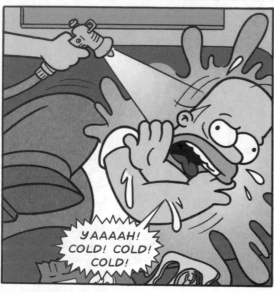

YAAAAH! COLD! COLD! COLD!

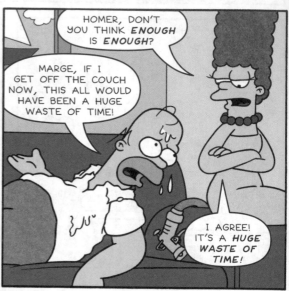

HOMER, DON'T YOU THINK *ENOUGH* IS *ENOUGH*?

MARGE, IF I GET OFF THE COUCH NOW, THIS ALL WOULD HAVE BEEN A HUGE WASTE OF TIME!

I AGREE! IT'S A *HUGE WASTE OF TIME!*

THEN, IF WE *AGREE*, WHY ARE WE FIGHTING?

OH, MRS. SIMPSON, YOU'RE OUT OF NACHO CHIPS AND SALSA!

HRMMM...

YOU'RE STILL HERE? IT'S *SIX O'CLOCK*, WHO'S READING THE *NEWS*?

NO PROBLEM. A NICE OLD MAN WHO DROPPED BY FOR A VISIT SAID HE'D *COVER* FOR ME!

AND THAT'S WHY LUMPY OATMEAL IS WHAT *REALLY* KILLED KAISER WILHELM!

IN OTHER NEWS, ALL YOUNG PEOPLE ARE OUT TO GET YOU!

A NEW STUDY SHOWS THEY PLAN TO PUT US ALL IN CAMPS AND FORCE US TO MAKE *CANDY* AND *RAP MUSIC!*

THREAT OR MENACE?

AUTHORITIES ADVISE EVERYONE TO ACT NOW!

SPANK AT WILL, AMERICA!

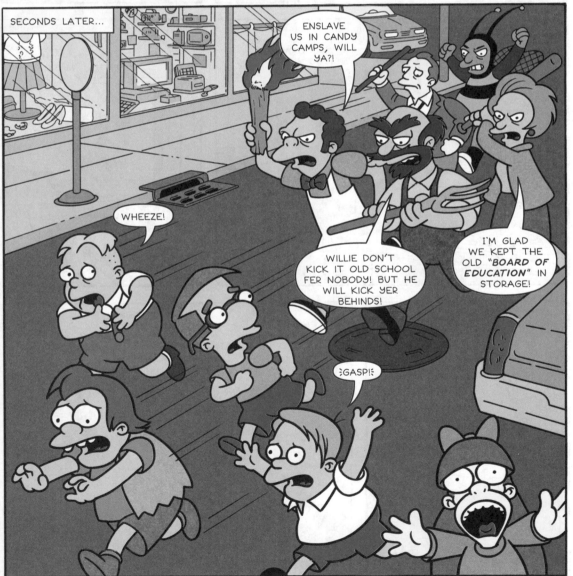

SECONDS LATER...

ENSLAVE US IN CANDY CAMPS, WILL YA?!

WHEEZE!

WILLIE DON'T KICK IT OLD SCHOOL FER NOBODY! BUT HE WILL KICK YER BEHINDS!

I'M GLAD WE KEPT THE OLD *"BOARD OF EDUCATION"* IN STORAGE!

¡GASP!¡

ONE MONTH LATER...

CHANGE THE CHANNEL, BROCKMAN! YOU'RE CLOSER TO THE REMOTE CONTROL!

SORRY, I CAN'T GET *INVOLVED*. AS A REPORTER, I HAVE TO STAY *DETACHED*. NOW, WHERE'S MARGE WITH MY LUNCH?

¡GASP!¿

SNIFF!

SNIFF!

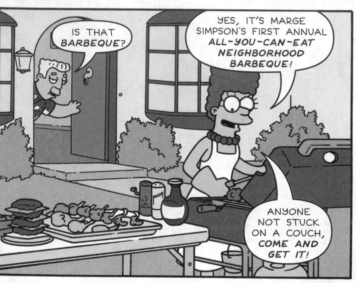

IS THAT *BARBEQUE*?

YES, IT'S MARGE SIMPSON'S FIRST ANNUAL *ALL-YOU-CAN-EAT NEIGHBORHOOD BARBEQUE*!

ANYONE NOT STUCK ON A COUCH, *COME AND GET IT*!

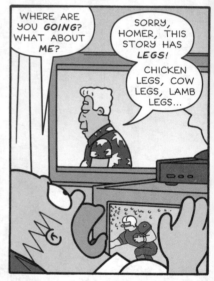

WHERE ARE YOU *GOING*? WHAT ABOUT *ME*?

SORRY, HOMER, THIS STORY HAS *LEGS*!

CHICKEN LEGS, COW LEGS, LAMB LEGS...

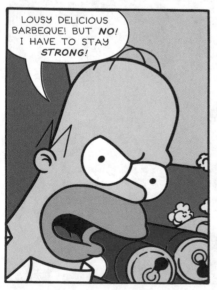

LOUSY DELICIOUS BARBEQUE! BUT *NO*! I HAVE TO STAY *STRONG*!

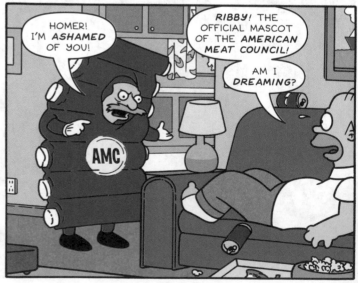

HOMER! I'M *ASHAMED* OF YOU!

RIBBY! THE OFFICIAL MASCOT OF THE *AMERICAN MEAT COUNCIL*!

AM I *DREAMING*?

AMC

HOMER, IT'S YOUR *AMERICAN DUTY* TO GET OUT THERE AND EAT AS MUCH MEAT AS YOU CAN!

BUT *THE COUCH!* MY *DREAMS!*

DON'T JUST DO IT FOR ME! THINK OF THE *FARMERS,* THE *GROCERS,* AND THE *SLAUGHTER-HOUSE WORKERS!*

I'LL DO IT! ⊰SOB⊱ FOR THE *SLAUGHTERHOUSE WORKERS!*

MARGE, LOAD UP MY PLATE!

HOMER! YOU'RE *UP!* THANK HEAVEN!

AND THANK *YOU,* RIBBY!

THE MEAT INDUSTRY IS ALWAYS HERE FOR YOU, MARGE!

WHAT'S WRONG, LISA? ⊰MUNCH!⊱ DAD'S OFF THE COUCH AND THINGS ARE *BACK TO NORMAL!*

THAT'S THE PROBLEM. NOTHING HAPPENED TO ME. I TRIED SO HARD, BUT I'LL NEVER GET A PLANT NAMED AFTER ME!

I GUESS I'LL JUST TRY AND GET *SOMETHING* TO EAT WITHOUT *BLOOD* IN IT!

YOU GOT SOMETHING AGAINST *BLOOD*?!

EASY, FRANK, SHE'S NOT WORTH IT!

HEY, DAD, YOU'VE GOT SOMETHING ON YOUR *BACK*!

MUNCH! CRUNCH!

YOINK!

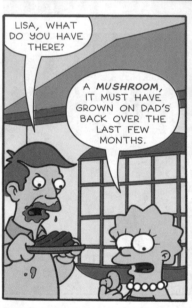

LISA, WHAT DO YOU HAVE THERE?

A *MUSHROOM*, IT MUST HAVE GROWN ON DAD'S BACK OVER THE LAST FEW MONTHS.

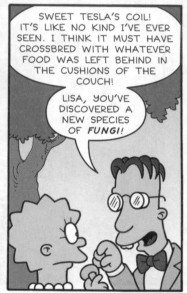

SWEET TESLA'S COIL! IT'S LIKE NO KIND I'VE EVER SEEN. I THINK IT MUST HAVE CROSSBRED WITH WHATEVER FOOD WAS LEFT BEHIND IN THE CUSHIONS OF THE COUCH!

LISA, YOU'VE DISCOVERED A NEW SPECIES OF *FUNGI*!

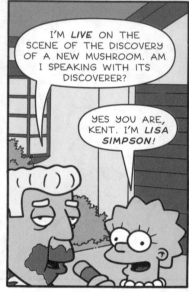

I'M *LIVE* ON THE SCENE OF THE DISCOVERY OF A NEW MUSHROOM. AM I SPEAKING WITH ITS DISCOVERER?

YES YOU ARE, KENT. I'M *LISA SIMPSON*!

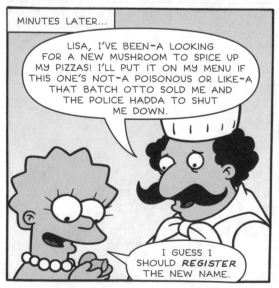

MINUTES LATER...

LISA, I'VE BEEN-A LOOKING FOR A NEW MUSHROOM TO SPICE UP MY PIZZAS! I'LL PUT IT ON MY MENU IF THIS ONE'S NOT-A POISONOUS OR LIKE-A THAT BATCH OTTO SOLD ME AND THE POLICE HADDA TO SHUT ME DOWN.

I GUESS I SHOULD *REGISTER* THE NEW NAME.

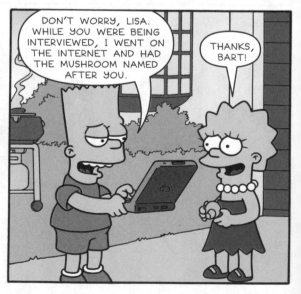

DON'T WORRY, LISA. WHILE YOU WERE BEING INTERVIEWED, I WENT ON THE INTERNET AND HAD THE MUSHROOM NAMED AFTER YOU.

THANKS, BART!

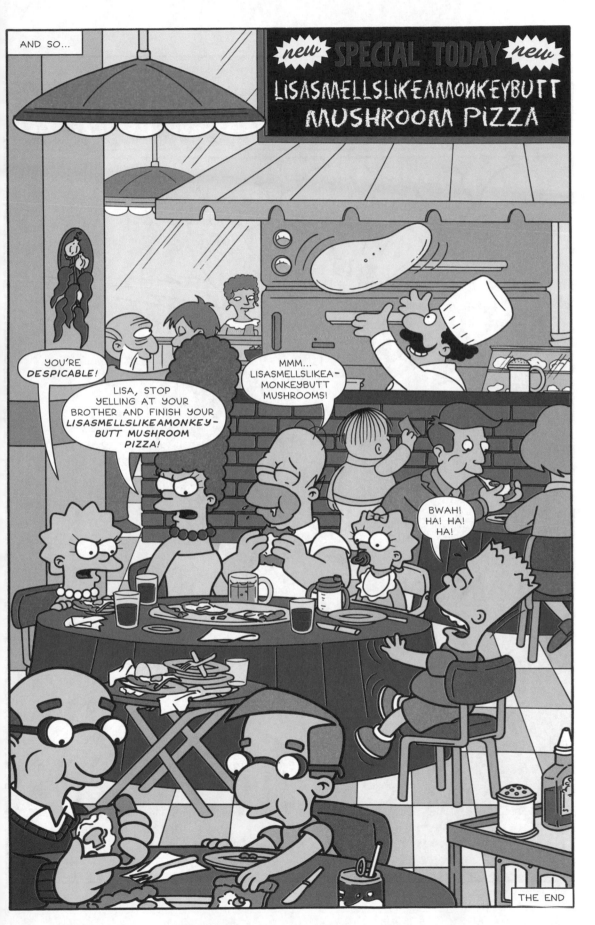

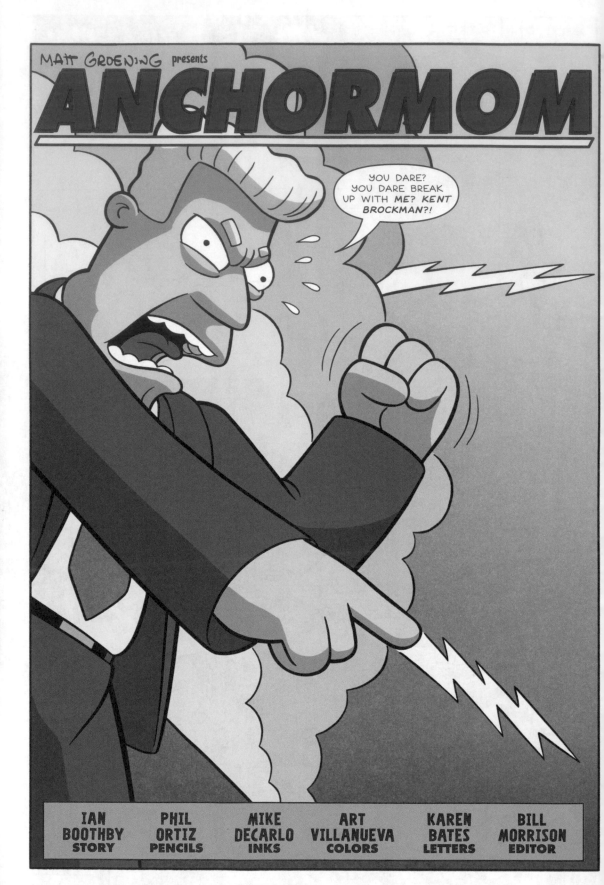

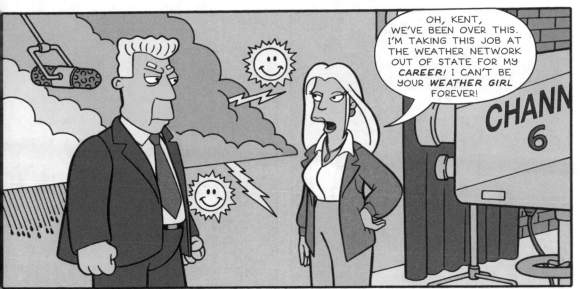

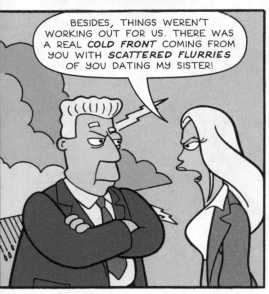

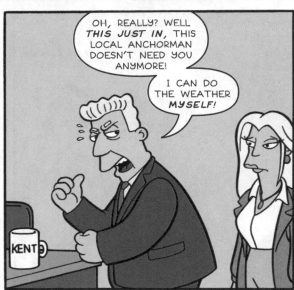

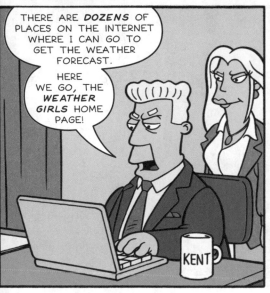

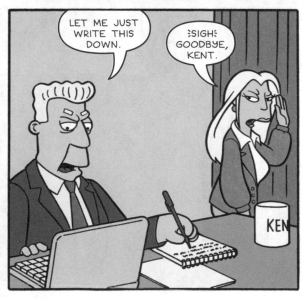

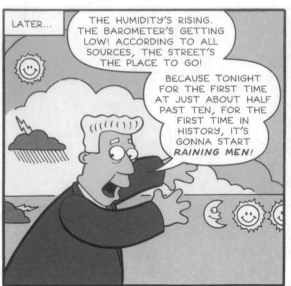

LATER...

THE HUMIDITY'S RISING. THE BAROMETER'S GETTING LOW! ACCORDING TO ALL SOURCES, THE STREET'S THE PLACE TO GO!

BECAUSE TONIGHT FOR THE FIRST TIME AT JUST ABOUT HALF PAST TEN, FOR THE FIRST TIME IN HISTORY, IT'S GONNA START *RAINING MEN!*

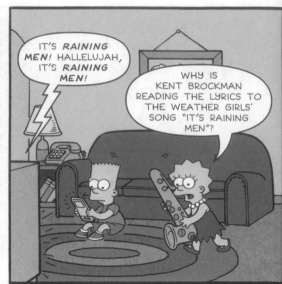

IT'S *RAINING MEN!* HALLELUJAH, IT'S *RAINING MEN!*

WHY IS KENT BROCKMAN READING THE LYRICS TO THE WEATHER GIRLS' SONG "IT'S RAINING MEN"?

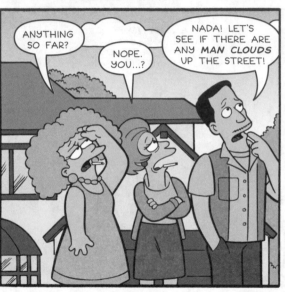

ANYTHING SO FAR?

NOPE. YOU...?

NADA! LET'S SEE IF THERE ARE ANY *MAN CLOUDS* UP THE STREET!

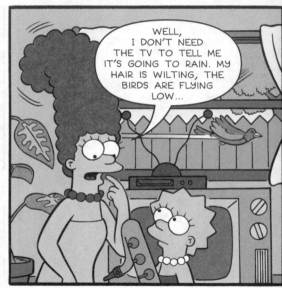

WELL, I DON'T NEED THE TV TO TELL ME IT'S GOING TO RAIN. MY HAIR IS WILTING, THE BIRDS ARE FLYING LOW...

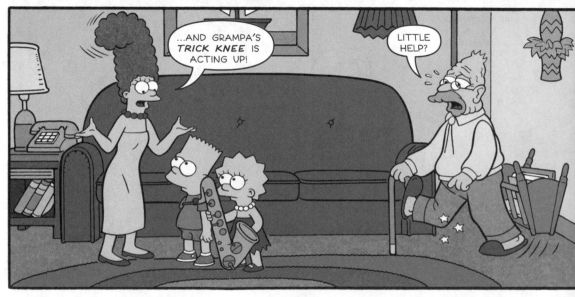

...AND GRAMPA'S *TRICK KNEE* IS ACTING UP!

LITTLE HELP?

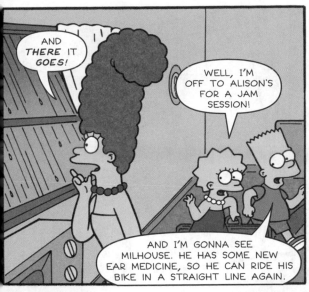

AND *THERE* IT GOES!

WELL, I'M OFF TO ALISON'S FOR A JAM SESSION!

AND I'M GONNA SEE MILHOUSE. HE HAS SOME NEW EAR MEDICINE, SO HE CAN RIDE HIS BIKE IN A STRAIGHT LINE AGAIN.

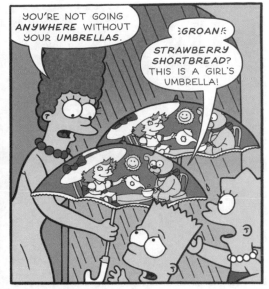

YOU'RE NOT GOING *ANYWHERE* WITHOUT YOUR *UMBRELLAS.*

≷GROAN≷ *STRAWBERRY SHORTBREAD?* THIS IS A GIRL'S UMBRELLA!

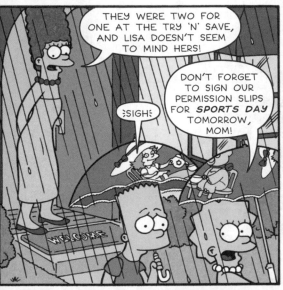

THEY WERE TWO FOR ONE AT THE TRY 'N' SAVE, AND LISA DOESN'T SEEM TO MIND HERS!

DON'T FORGET TO SIGN OUR PERMISSION SLIPS FOR *SPORTS DAY* TOMORROW, MOM!

≷SIGH≷

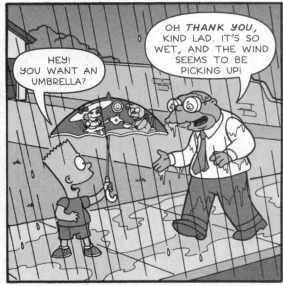

HEY! YOU WANT AN UMBRELLA?

OH *THANK YOU,* KIND LAD. IT'S SO WET, AND THE WIND SEEMS TO BE PICKING UP!

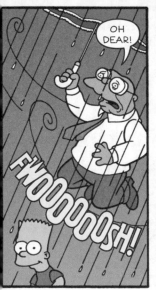

OH DEAR!

FWOOOOOOSH!

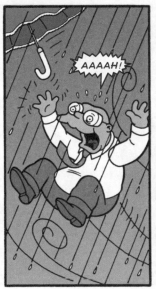

AAAAH!

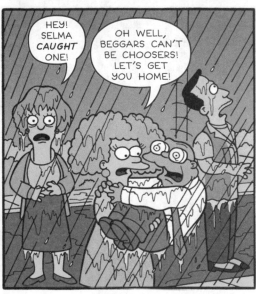

HEY! SELMA *CAUGHT* ONE!

OH WELL, BEGGARS CAN'T BE CHOOSERS! LET'S GET YOU HOME!

WAAAAAAH!

COMING, MAGGIE!

WHAT IS IT, SWEETIE? DID YOU HAVE A *NIGHTMARE*? DON'T BE SCARED!

THERE'S NO MONSTER IN THE CLOSET!

I'LL *SHOW* YOU!

GRRRR!

GNASH!

SEE, IT'S JUST YOUR FATHER EATING...WHAT *IS* THAT?

A JERK CHICKEN I BROUGHT BACK FROM *JAMAICA*!

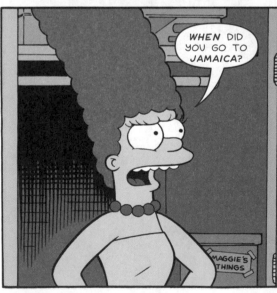

WHEN DID YOU GO TO JAMAICA?

MAGGIE'S THINGS

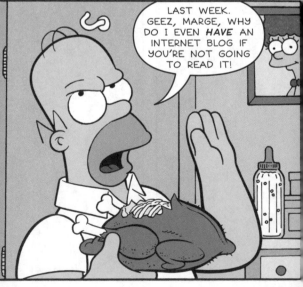

LAST WEEK. GEEZ, MARGE, WHY DO I EVEN *HAVE* AN INTERNET BLOG IF YOU'RE NOT GOING TO READ IT!

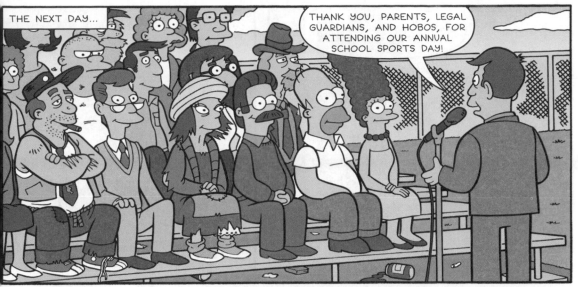

THE NEXT DAY...

THANK YOU, PARENTS, LEGAL GUARDIANS, AND HOBOS, FOR ATTENDING OUR ANNUAL SCHOOL SPORTS DAY!

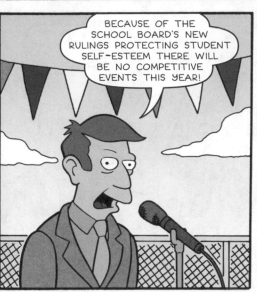

BECAUSE OF THE SCHOOL BOARD'S NEW RULINGS PROTECTING STUDENT SELF-ESTEEM THERE WILL BE NO COMPETITIVE EVENTS THIS YEAR!

"FIRST UP, THE *SACK RACE!*"

OW! I HAVE A *CRAMP!*

I'LL GIVE YOU SOMETHING TO CRAMP ABOUT!

"THE TUG OF WAR! NOW CALLED "THE TUG OF PEACEFUL CO-EXISTENCE!"

UGH!

ACK!

UNF!

"AND THE EGG AND SPOON RACE!"

THAT'S *WILLIE'S EGG!* I NEED TO STUFF IT INSIDE A SHEEP FOR ME BREAKFAST!

SHORTLY...

AND SO *EVERY-BODY'S* A WINNER AT THIS *POINTLESS, POINTLESS* EVENT!

♪WE ARE THE CHAMPIONS, MY FRIEND!♪

PLACE | 1ST PLACE | 1ST P

THIS IS KENT BROCKMAN ON A *VERY, VERY* SLOW NEWS-DAY REPORTING! I'LL BE BACK WITH THE WEATHER AFTER THIS MESSAGE FROM *KRUSTY BURGER!*

HEY, HEY, KIDS! BE SURE TO TRY OUR NEW *HIGH-FIBER* KRUSTY BURGER! ORDER YOURS NOW FOR HERE OR TO GO! AND, I MEAN, *TO GO!* RIGHT, COLON-EY?

I'LL SAY!

ON AN UNRELATED SUBJECT, ALL KRUSTY RESTROOMS HAVE PAY TOILETS NOW, SO BRING MONEY! NO EXCEPTIONS!

AW GEE, WHY'D OL' GIL HAVE TO GO AND *SUPER-SIZE?*

MEN

AND WE'RE BACK. THE WEATHER FOR TODAY SHOULD BE...LET'S SAY... SUNNY AND WARM WITH TEMPERATURES...

EXCUSE ME, MR. BROCKMAN?

WE'RE *LIVE* ON THE AIR!

I KNOW. IT'S JUST THAT YOUR WEATHER REPORT IS *WRONG!*

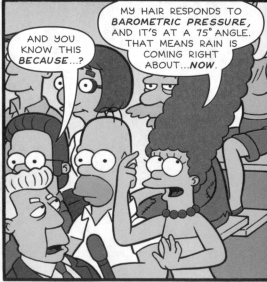

AND YOU KNOW THIS *BECAUSE*...?

MY HAIR RESPONDS TO *BAROMETRIC PRESSURE,* AND IT'S AT A 75° ANGLE. THAT MEANS RAIN IS COMING RIGHT ABOUT...*NOW.*

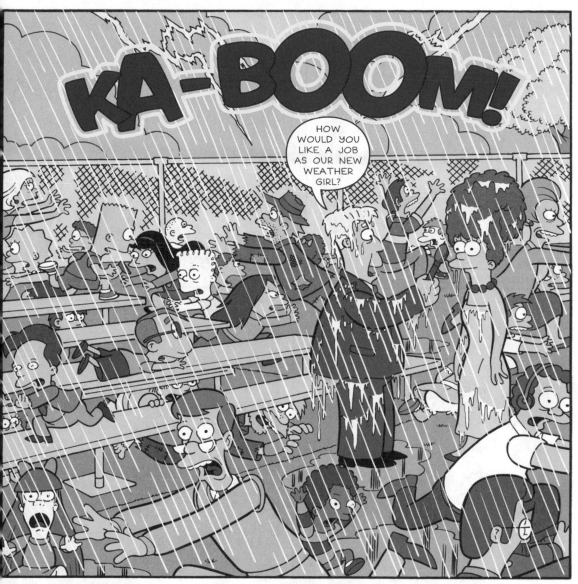

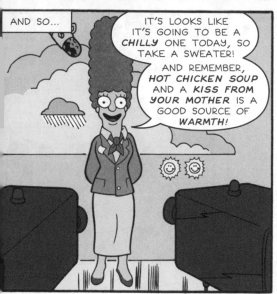

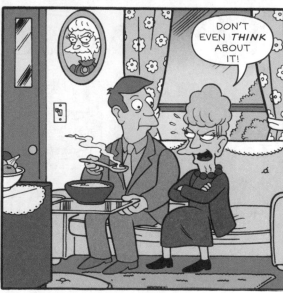

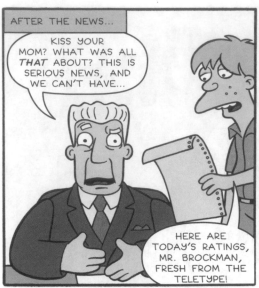

AFTER THE NEWS...

KISS YOUR MOM? WHAT WAS ALL *THAT* ABOUT? THIS IS SERIOUS NEWS, AND WE CAN'T HAVE...

HERE ARE TODAY'S RATINGS, MR. BROCKMAN, FRESH FROM THE TELETYPE!

ARRROOOO!

WHAM!

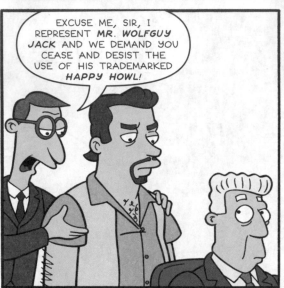

EXCUSE ME, SIR, I REPRESENT *MR. WOLFGUY JACK* AND WE DEMAND YOU CEASE AND DESIST THE USE OF HIS TRADEMARKED *HAPPY HOWL!*

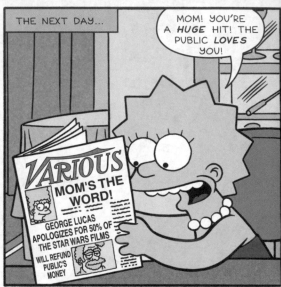

THE NEXT DAY...

MOM! YOU'RE A *HUGE* HIT! THE PUBLIC *LOVES* YOU!

VARIOUS

MOM'S THE WORD!

GEORGE LUCAS APOLOGIZES FOR 50% OF THE STAR WARS FILMS

WILL REFUND PUBLIC'S MONEY

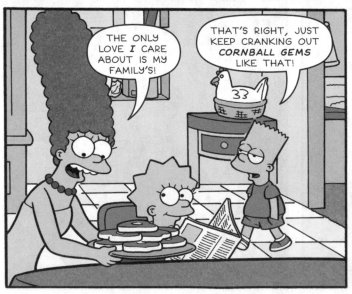

THE ONLY LOVE *I* CARE ABOUT IS MY FAMILY'S!

THAT'S RIGHT, JUST KEEP CRANKING OUT *CORNBALL GEMS* LIKE THAT!

33

WAAAAAAH!

OH, SOUNDS LIKE SOMETHING SCARED *MAGGIE* AGAIN!

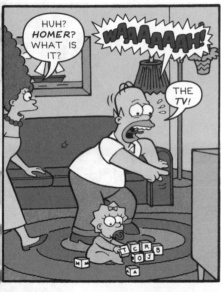

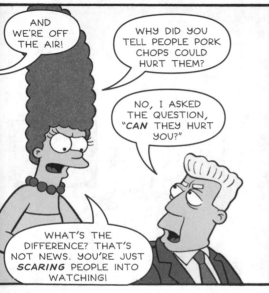

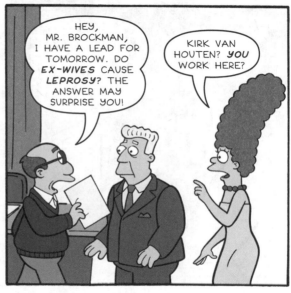

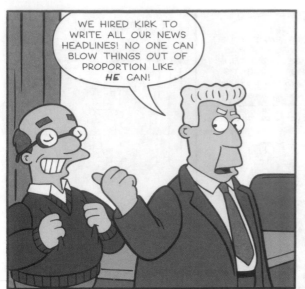

WE HIRED KIRK TO WRITE ALL OUR NEWS HEADLINES! NO ONE CAN BLOW THINGS OUT OF PROPORTION LIKE *HE* CAN!

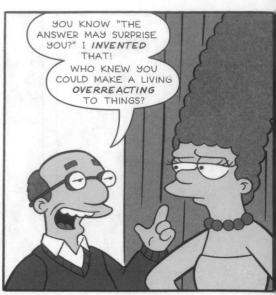

YOU KNOW "THE ANSWER MAY SURPRISE YOU?" I *INVENTED* THAT!

WHO KNEW YOU COULD MAKE A LIVING *OVERREACTING* TO THINGS?

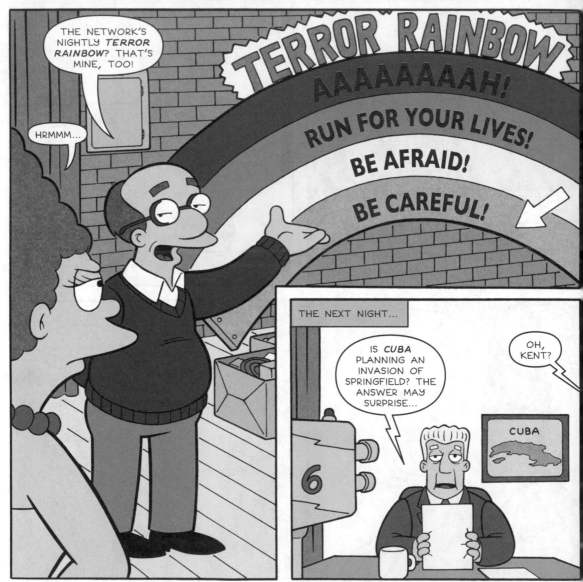

THE NETWORK'S NIGHTLY *TERROR RAINBOW*? THAT'S MINE, TOO!

HRMMM...

TERROR RAINBOW

AAAAAAAAH!

RUN FOR YOUR LIVES!

BE AFRAID!

BE CAREFUL!

THE NEXT NIGHT...

IS *CUBA* PLANNING AN INVASION OF SPRINGFIELD? THE ANSWER MAY SURPRISE...

OH, KENT?

CUBA

6

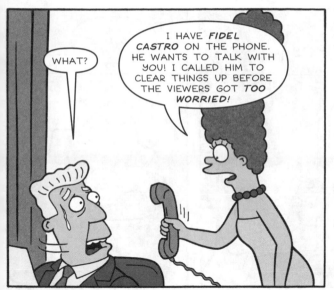

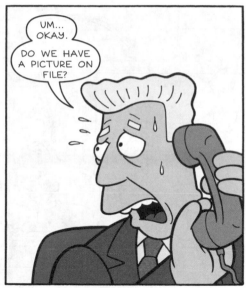

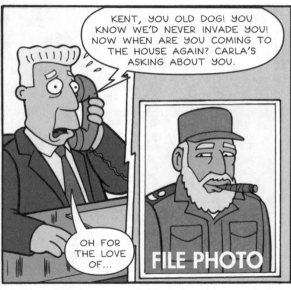

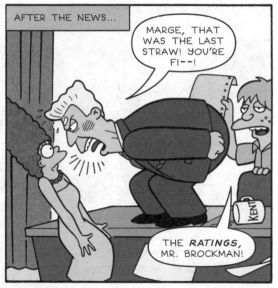

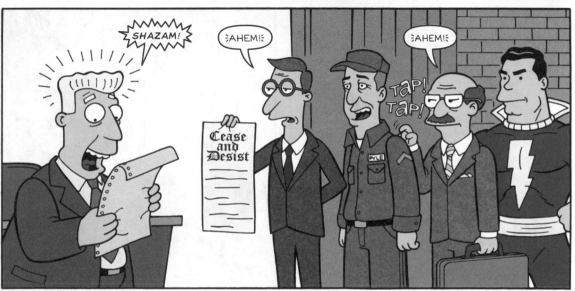

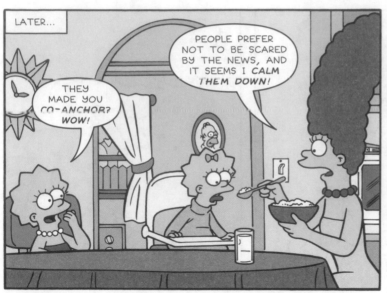

LATER...

THEY MADE YOU *CO-ANCHOR?* WOW!

PEOPLE PREFER NOT TO BE SCARED BY THE NEWS, AND IT SEEMS I *CALM THEM DOWN!*

I'M SO *PROUD* OF YOU, MOM!

AREN'T *YOU* PROUD OF HER, DAD?

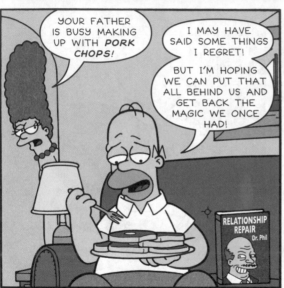

YOUR FATHER IS BUSY MAKING UP WITH *PORK CHOPS!*

I MAY HAVE SAID SOME THINGS I REGRET!

BUT I'M HOPING WE CAN PUT THAT ALL BEHIND US AND GET BACK THE MAGIC WE ONCE HAD!

RELATIONSHIP REPAIR
Dr. Phil

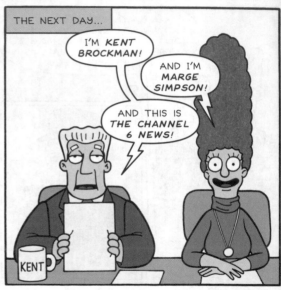

THE NEXT DAY...

I'M *KENT BROCKMAN!*

AND I'M *MARGE SIMPSON!*

AND THIS IS *THE CHANNEL 6 NEWS!*

KENT

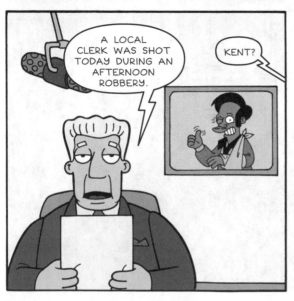

A LOCAL CLERK WAS SHOT TODAY DURING AN AFTERNOON ROBBERY.

KENT?

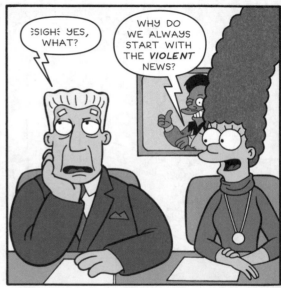

:SIGH: YES, WHAT?

WHY DO WE ALWAYS START WITH THE *VIOLENT* NEWS?

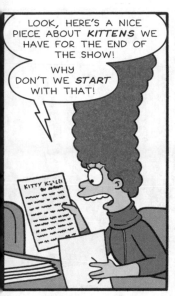

LOOK, HERE'S A NICE PIECE ABOUT **KITTENS** WE HAVE FOR THE END OF THE SHOW!

WHY DON'T WE **START** WITH THAT!

THAT'S **FILLER**, MARGE! YOU DON'T **LEAD** WITH FILLER!

LET'S TRY IT AND SEE!

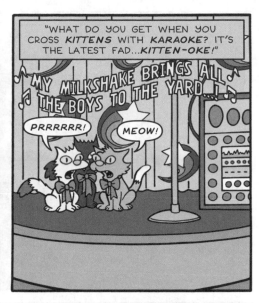

"WHAT DO YOU GET WHEN YOU CROSS **KITTENS** WITH **KARAOKE**? IT'S THE LATEST FAD...**KITTEN-OKE!**"

MY MILKSHAKE BRINGS ALL THE BOYS TO THE YARD...!

PRRRRRR!

MEOW!

AFTER THE SHOW...

THE RATINGS, MR. BROCKMAN...

YEAH, YEAH...HOORAY.

LATER...

WOW, BART, BOTH OF US HAVE PARENTS WORKING ON THE NEWS! HOW COOL IS **THAT**?

CHANNEL 6

I WONDER IF THE NEWSROOM WILL LOOK LIKE IT DOES ON OLD TV SHOWS.

NEW YORK LONDON MOSCOW

YEP, PRETTY MUCH!

THE HOT CHOCOLATE IN MY DRESSING ROOM HAS *NO MARSHMALLOWS!* AND I CAN'T READ THE NEWS WITHOUT MY *HOT CHOCOLATE!*

I'LL ALERT THE *SWISS* CONSULATE!

SEE THAT YOU DO!

THAT KENT IS ABOUT AS BRIGHT AS A WET CANDLE!

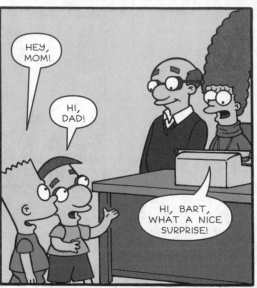

HEY, MOM!

HI, DAD!

HI, BART, WHAT A NICE SURPRISE!

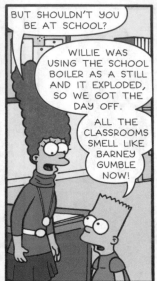

BUT SHOULDN'T YOU BE AT SCHOOL?

WILLIE WAS USING THE SCHOOL BOILER AS A STILL AND IT EXPLODED, SO WE GOT THE DAY OFF.

ALL THE CLASSROOMS SMELL LIKE BARNEY GUMBLE NOW!

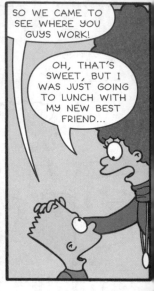

SO WE CAME TO SEE WHERE YOU GUYS WORK!

OH, THAT'S SWEET, BUT I WAS JUST GOING TO LUNCH WITH MY NEW BEST FRIEND...

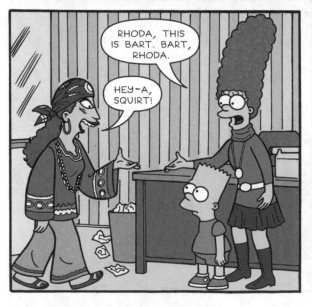

RHODA, THIS IS BART. BART, RHODA.

HEY-A, SQUIRT!

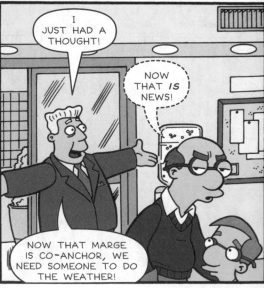

I JUST HAD A THOUGHT!

NOW THAT *IS* NEWS!

NOW THAT MARGE IS CO-ANCHOR, WE NEED SOMEONE TO DO THE WEATHER!

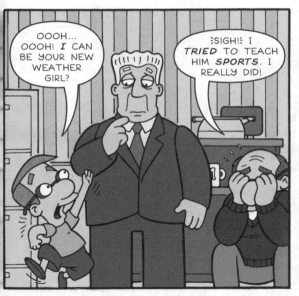

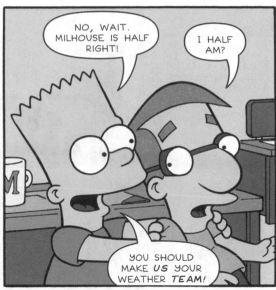

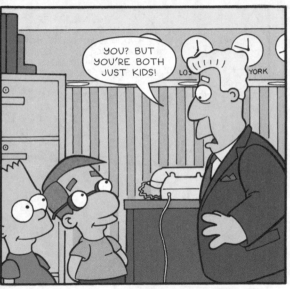

73

THE NEXT DAY...

AND TO RECAP OUR TOP STORY, THE BABY *PANDA* THAT WAS LOST IN THE PARK IN CHINA FOUND ITS MOMMY, AND EVERYTHING TURNED OUT FINE.

¡GROAN!?

AND NOW, I'D LIKE YOU TO MEET OUR *NEW WEATHER TEAM*, BART AND MILHOUSE!

YO! YO! YO! SPRINGFIELD! WHAT'S UP? IT'S "THE MORNING WEATHER ZOO WITH BART AND THE GANG!"

AND *THE GANG*? WE AGREED IT WOULD BE "BART AND THE *MILHOUSE VAN HOUTEN EXPERIENCE!*"

YOU AND YOUR *DAD* AGREED ON THAT! WE'LL TALK LATER!

THE WEATHER TODAY SHOULD BE SUNNY AND WARM, SO IF YOU'RE PLANNING TO TAKE YOUR MOTHER AND BOSS OUT FOR A PICNIC, THEN GO FOR IT!

WAIT A MINUTE! THAT'S NOT THE WEATHER I GAVE BART.

LATER THAT DAY...

SEYMOUR!

SKINNER!

KA-BOOM!

BART!

74

AND AT THE NEXT NEWSCAST...

WE'VE GOT A BIG SHOUT OUT GOING TO *EDNA KRABAPPEL*, WHO TURNS *100* TODAY!

THERE SHE IS! THE ONE I SEEN ON THE *TELLY*!

THANKS FOR THE TIP OFF, WILLIE! EDNA KRABAPPEL, YOU'RE UNDER ARREST FOR FAILURE TO ADHERE TO MANDATORY RETIREMENT-AGE LAW!

WHAT THE...?

BULLE

TEACHER'S LOUNGE

WHAT ARE YOU TALKING ABOUT? I'M ONLY...LET'S SAY...*40!*

YOU'RE GOING AWAY FOR A *LONG* TIME, GRANDMA!

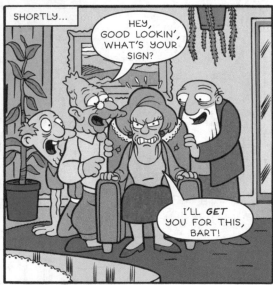

SHORTLY...

HEY, GOOD LOOKIN', WHAT'S YOUR SIGN?

I'LL *GET* YOU FOR THIS, BART!

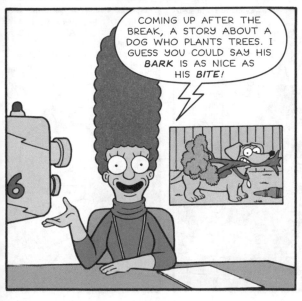

COMING UP AFTER THE BREAK, A STORY ABOUT A DOG WHO PLANTS TREES. I GUESS YOU COULD SAY HIS *BARK* IS AS NICE AS HIS *BITE!*

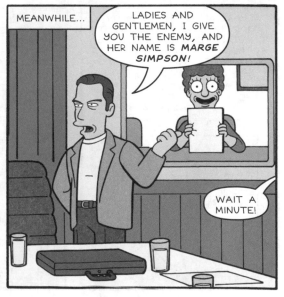

MEANWHILE...

LADIES AND GENTLEMEN, I GIVE YOU THE ENEMY, AND HER NAME IS *MARGE SIMPSON!*

WAIT A MINUTE!

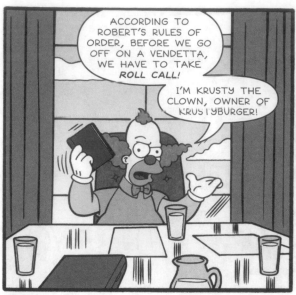

ACCORDING TO ROBERT'S RULES OF ORDER, BEFORE WE GO OFF ON A VENDETTA, WE HAVE TO TAKE *ROLL CALL!*

I'M KRUSTY THE CLOWN, OWNER OF KRUSTYBURGER!

I'M *GARTH MOTHERLOVING,* PRESIDENT OF THE *MOTHERLOVING SUGAR COMPANY!*

AND YOU PUNKS SURE AS SHINOLA KNOW WHO I AM. LITTLE DOLLY OF LITTLE DOLLY'S CAKES AND SWEET BREADS!

NOW LET'S CUT THE *BULL-PUCKY* AND FIND A WAY TO *STIFLE* THIS *BROAD!*

HEY, HEY! SO THE NEWS ISN'T SCARY ANYMORE. WHAT'S THE BIG DEAL?

OH, I'LL *TELL YOU* WHAT THE BIG DEAL IS!

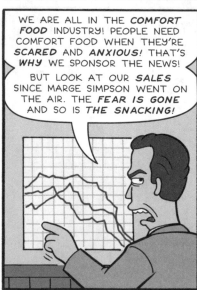

WE ARE ALL IN THE *COMFORT FOOD* INDUSTRY! PEOPLE NEED COMFORT FOOD WHEN THEY'RE *SCARED* AND *ANXIOUS!* THAT'S *WHY* WE SPONSOR THE NEWS!

BUT LOOK AT OUR *SALES* SINCE MARGE SIMPSON WENT ON THE AIR. THE *FEAR IS GONE* AND SO IS *THE SNACKING!*

WE NEED TO TEACH THIS TOWN THE MEANING OF FEAR AGAIN.

BUT HOW? BOMB THREAT? BIO-TERRORISM? I CAN MAKE A FEW PHONE CALLS!

HOLD THE PHONE! I THINK I GOT A WAY TO GET MARGE OUT OF THE PICTURE *AND* BRING BACK THE FEAR AT THE SAME TIME! GET OUR AD DEPARTMENT ON THE PHONE!

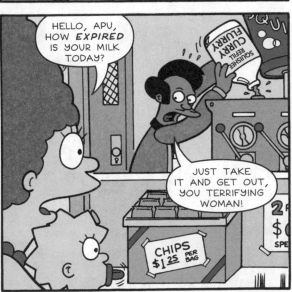

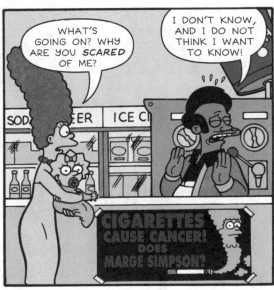

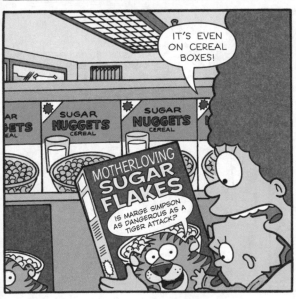

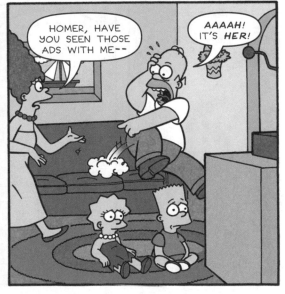

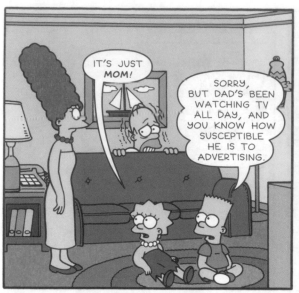

IT'S JUST **MOM**!

SORRY, BUT DAD'S BEEN WATCHING TV ALL DAY, AND YOU KNOW HOW SUSCEPTIBLE HE IS TO ADVERTISING.

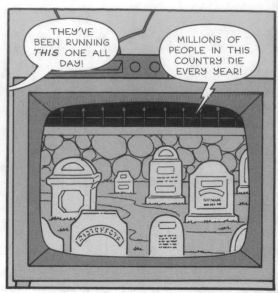

THEY'VE BEEN RUNNING **THIS** ONE ALL DAY!

MILLIONS OF PEOPLE IN THIS COUNTRY DIE EVERY YEAR!

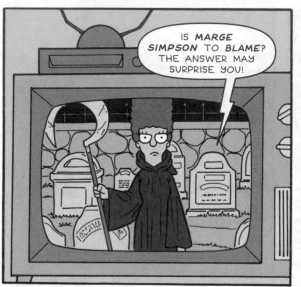

IS **MARGE SIMPSON** TO BLAME? THE ANSWER MAY SURPRISE YOU!

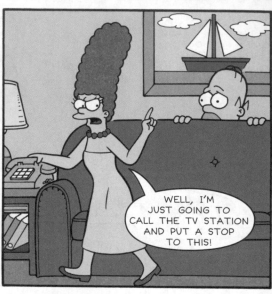

WELL, I'M JUST GOING TO CALL THE TV STATION AND PUT A STOP TO THIS!

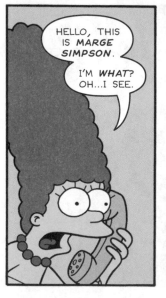

HELLO, THIS IS **MARGE SIMPSON**.

I'M **WHAT**? OH...I SEE.

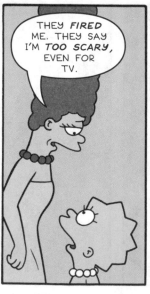

THEY **FIRED** ME. THEY SAY I'M **TOO SCARY**, EVEN FOR TV.

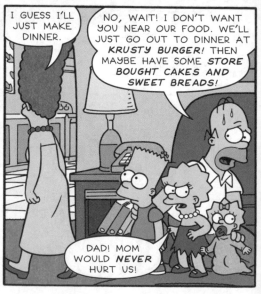

I GUESS I'LL JUST MAKE DINNER.

NO, WAIT! I DON'T WANT YOU NEAR OUR FOOD. WE'LL JUST GO OUT TO DINNER AT **KRUSTY BURGER**! THEN MAYBE HAVE SOME **STORE BOUGHT CAKES AND SWEET BREADS**!

DAD! MOM WOULD **NEVER** HURT US!

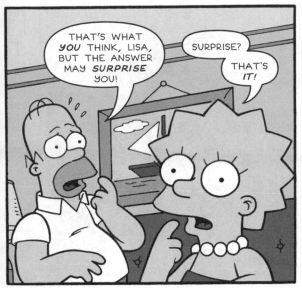

THAT'S WHAT *YOU* THINK, LISA, BUT THE ANSWER MAY *SURPRISE* YOU!

SURPRISE?

THAT'S *IT!*

BART! COME WITH ME!

YAAAAAA!

MILHOUSE ISN'T HERE RIGHT NOW. IT'S HIS MOTHER'S WEEKEND TO TURN HIM AGAINST ME!

MR. VAN HOUTEN, WE KNOW YOU WORKED ON THOSE ADS ABOUT OUR MOM!

I...ER...DON'T KNOW WHAT YOU'RE TALKING ABOUT!

THE AD ENDED WITH "THE ANSWER MAY SURPRISE YOU." THAT'S *YOUR* LINE!

:SIGH!: FINE, IT *WAS* ME. BUT I WAS HIRED BY...

...*THE NATIONAL LEAGUE OF COMFORT FOOD!*

WHAT THE @#%&!

:GASP:

HUH?

YOU CAN'T JUST *BARGE* IN HERE!

THAT'S WHAT YOUR *SIGN* SAYS!

DOORBELL BROKEN
BARGE RIGHT IN

OH...OKAY THEN!

WE KNOW YOU'RE TRYING TO MAKE OUR MOM LOOK BAD!

TOOTS, IT'S THAT *LIME GREEN NUMBER* SHE ALWAYS WEARS THAT MAKES HER *LOOK BAD.* WE JUST MADE PEOPLE *SCARED* OF HER!

SNAP!

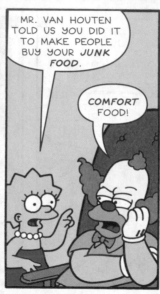

MR. VAN HOUTEN TOLD US YOU DID IT TO MAKE PEOPLE BUY YOUR *JUNK FOOD.*

COMFORT FOOD!

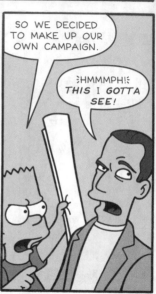

SO WE DECIDED TO MAKE UP OUR OWN CAMPAIGN.

⸬HMMMPH!⸬ *THIS* I *GOTTA SEE!*

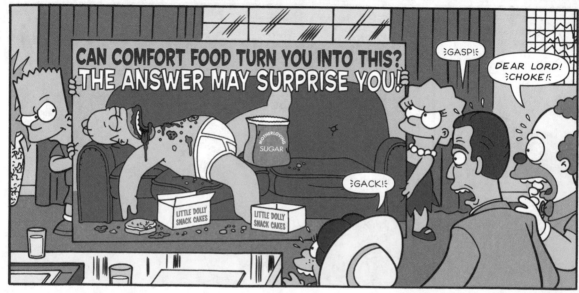

CAN COMFORT FOOD TURN YOU INTO THIS?
THE ANSWER MAY SURPRISE YOU!

⸬GASP!⸬

DEAR LORD! ⸬CHOKE!⸬

⸬GACK!⸬

MOTHERLOVING SUGAR

LITTLE DOLLY SNACK CAKES

LITTLE DOLLY SNACK CAKES

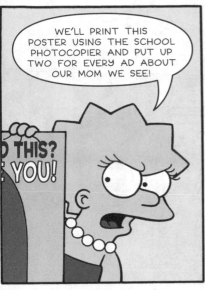

WE'LL PRINT THIS POSTER USING THE SCHOOL PHOTOCOPIER AND PUT UP TWO FOR EVERY AD ABOUT OUR MOM WE SEE!

WE CAN'T HAVE PEOPLE THINKING ABOUT *THAT* AND OUR *FOOD* AT THE SAME TIME!

YOU'VE GOT A REAL TWISTED, DARK-STREAK KIDS! I *RESPECT* THAT.

WE'LL DROP THE CAMPAIGN AGAINST YOUR MA! ANY *OTHER* DEMANDS?

YEAH, GET RID OF COLON-EY. HE *CREEPS* EVERYBODY OUT!

DONE!

YOU'VE NOT HEARD THE LAST OF *COLON-EY!*

AND SO...

WE'RE PLEASED TO WELCOME BACK MARGE SIMPSON TO THE CHANNEL 6 NEWS. AND WE APOLOGIZE FOR ALL THE *HORRIBLE, GRUESOME* THINGS WE WERE THINKING ABOUT YOU.

THANK YOU, KENT.

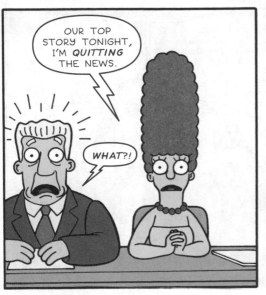

OUR TOP STORY TONIGHT, I'M *QUITTING* THE NEWS.

WHAT?!

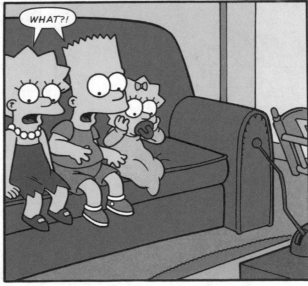

WHAT?!

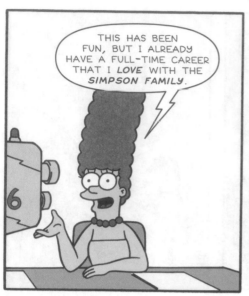

THIS HAS BEEN FUN, BUT I ALREADY HAVE A FULL-TIME CAREER THAT I *LOVE* WITH THE *SIMPSON FAMILY*.

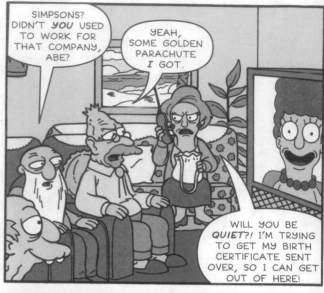

SIMPSONS? DIDN'T *YOU* USED TO WORK FOR THAT COMPANY, ABE?

YEAH, SOME GOLDEN PARACHUTE *I* GOT.

WILL YOU BE *QUIET*?! I'M TRYING TO GET MY BIRTH CERTIFICATE SENT OVER, SO I CAN GET OUT OF HERE!

BUT I WANT TO LEAVE YOU WITH THIS. YOU'LL HEAR A LOT OF *SCARY THINGS* WHEN YOU WATCH THE NEWS, BUT, REMEMBER, THERE'S A LOT OF *GOOD* OUT THERE HAPPENING, TOO!

AND IF YOU'RE SCARED? I THINK THAT IF YOU JUST TAKE THE TIME TO *HUG* THE PERSON NEXT TO YOU, YOU'LL FIND THE FEAR MIGHT JUST *GO AWAY*.

¡GAK!¿

MMMMM!

SHE'S CORRECT! MY FEAR OF JOSS WHEDON NEVER DOING ANOTHER TELEVISION SERIES IN THE BUFFY-VERSE IS FADING... FADING...

HEY, *STAY-PUFF MARSHMALLOW MAN*, THIS *AIN'T* THE KINDA TIP I WAS LOOKIN' FOR.

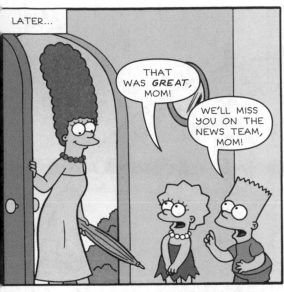

LATER...

THAT WAS *GREAT*, MOM!

WE'LL MISS YOU ON THE NEWS TEAM, MOM!

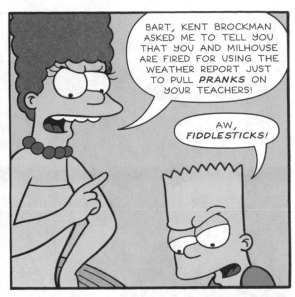

BART, KENT BROCKMAN ASKED ME TO TELL YOU THAT YOU AND MILHOUSE ARE FIRED FOR USING THE WEATHER REPORT JUST TO PULL *PRANKS* ON YOUR TEACHERS!

AW, *FIDDLESTICKS!*

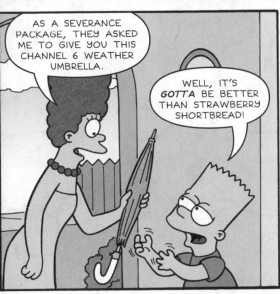

AS A SEVERANCE PACKAGE, THEY ASKED ME TO GIVE YOU THIS CHANNEL 6 WEATHER UMBRELLA.

WELL, IT'S *GOTTA* BE BETTER THAN STRAWBERRY SHORTBREAD!

A WEEK LATER...

HEY, BART, WE'RE GONNA HUCK *PUDDING CUPS* AT SKINNER'S CAR, WANNA COME?

SCHOOL LUNCH PUDDING
DO NOT GET IN EYES

SCHOOL LUNCH PUDDING
DO NOT GET IN EYES

NO THANKS, I'D BETTER STUDY FOR THAT BIG TEST THIS AFTERNOON.

AMERICAN HISTORY

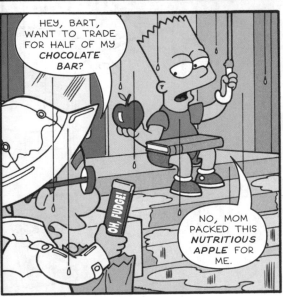

HEY, BART, WANT TO TRADE FOR HALF OF MY *CHOCOLATE BAR?*

OH, FUDGE!

NO, MOM PACKED THIS *NUTRITIOUS APPLE* FOR ME.

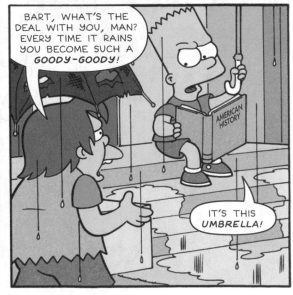

BART, WHAT'S THE DEAL WITH YOU, MAN? EVERY TIME IT RAINS YOU BECOME SUCH A *GOODY-GOODY!*

IT'S THIS *UMBRELLA!*

AMERICAN HISTORY

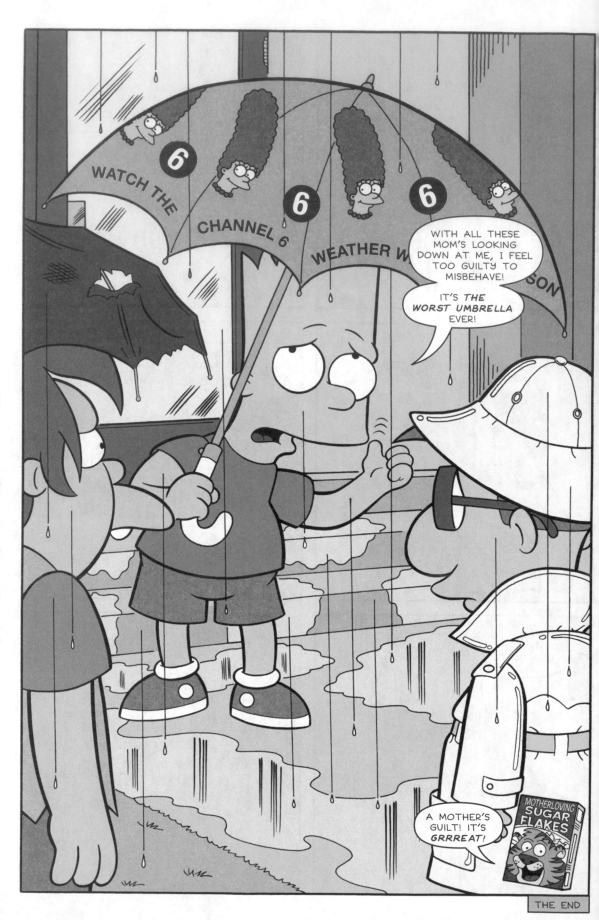

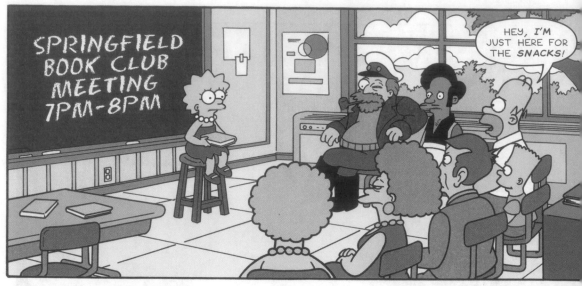

SPRINGFIELD BOOK CLUB MEETING 7PM-8PM

HEY, *I'M* JUST HERE FOR THE *SNACKS*!

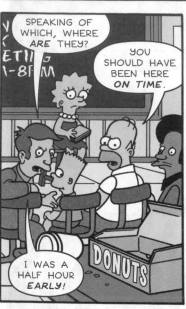

SPEAKING OF WHICH, WHERE *ARE* THEY?

YOU SHOULD HAVE BEEN HERE ON *TIME*.

I WAS A HALF HOUR *EARLY!*

DONUTS

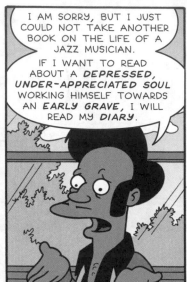

I AM SORRY, BUT I JUST COULD NOT TAKE ANOTHER BOOK ON THE LIFE OF A JAZZ MUSICIAN.

IF I WANT TO READ ABOUT A *DEPRESSED, UNDER-APPRECIATED SOUL* WORKING HIMSELF TOWARDS AN *EARLY GRAVE*, I WILL READ MY *DIARY*.

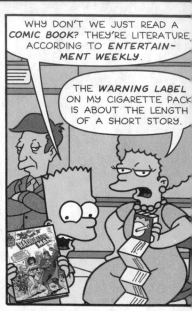

WHY DON'T WE JUST READ A *COMIC BOOK*? THEY'RE LITERATURE, ACCORDING TO *ENTERTAINMENT WEEKLY*.

THE *WARNING LABEL* ON MY CIGARETTE PACK IS ABOUT THE LENGTH OF A SHORT STORY.

I'VE GOT A *GOOD BOOK* RIGHT HERE!

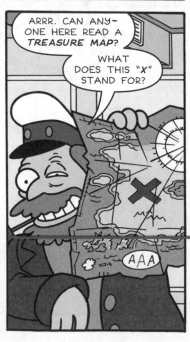

ARRR. CAN ANY-ONE HERE READ A *TREASURE MAP*?

WHAT DOES THIS "*X*" STAND FOR?

AAA

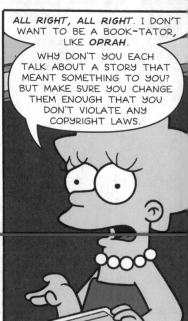

ALL RIGHT, ALL RIGHT. I DON'T WANT TO BE A BOOK-TATOR, LIKE *OPRAH*.

WHY DON'T YOU EACH TALK ABOUT A STORY THAT MEANT SOMETHING TO YOU? BUT MAKE SURE YOU CHANGE THEM ENOUGH THAT YOU DON'T VIOLATE ANY COPYRIGHT LAWS.

I HAVE ONE. IMAGINE IF YOU WILL, A BAR WHERE SAILORS GATHER AFTER A HARD DAY AT SEA...

SALTY'S
SEA CHANTEY KARAOKE 9PM-11PM

OH MY GOSH, IS *THAT*...?

I'LL ASK HIM.

ARE YOU THE BARTENDER?

JA' THINK I'M A COWBOY?

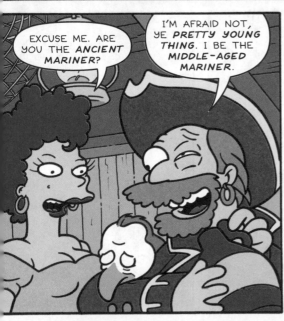

EXCUSE ME. ARE YOU THE *ANCIENT MARINER*?

I'M AFRAID NOT, YE *PRETTY YOUNG THING*. I BE THE MIDDLE-AGED MARINER.

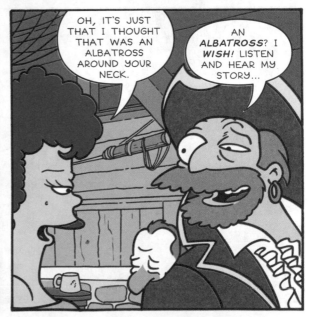

OH, IT'S JUST THAT I THOUGHT THAT WAS AN ALBATROSS AROUND YOUR NECK.

AN *ALBATROSS*? I *WISH!* LISTEN AND HEAR MY STORY...

RIME OF THE MIDDLE-AGED MARINER

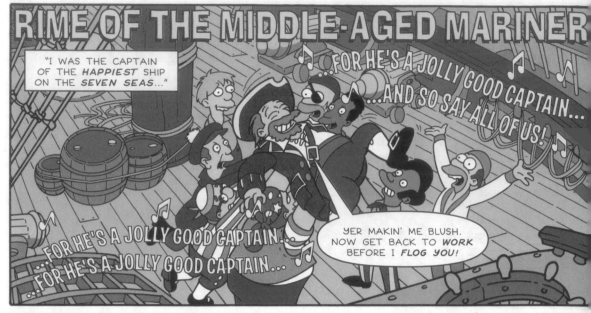

"I WAS THE CAPTAIN OF THE *HAPPIEST* SHIP ON THE *SEVEN SEAS*..."

♪ ...FOR HE'S A JOLLY GOOD CAPTAIN... ...AND SO SAY ALL OF US! ♪

...FOR HE'S A JOLLY GOOD CAPTAIN... ...FOR HE'S A JOLLY GOOD CAPTAIN...

YER MAKIN' ME BLUSH. NOW GET BACK TO *WORK* BEFORE I *FLOG YOU!*

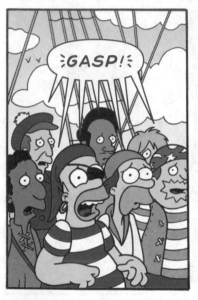

¡GASP!¿

FLOG YOU...*WITH LOVE!*

AWWWWW.

HEY, CAN YOU SPARE SOME *FOOD*?

WHAT? WHO *BE* THERE?

A *MERMAID*?

CAN YA HELP *OL' GULL* OUT? SPARE A *FRENCH FRY*? I'M SO LOW ON POTASSIUM MY TAIL FEATHERS ARE FALLING OUT!

SEE?

GAAR! FINE! GET THAT THING *OUTTA* MY *FACE,* AND I'LL GIVE YA A *JOB!*

A *JOB?* OH I WON'T LET YOU DOWN. *NO-SIREE-BOB!*

AHHRR...

LATER...

HEY, CAPTAIN! THIS IS *GREAT CHOWDER!* WHAT IS THAT FLAVOR? *CHICKEN?*

YOU'LL HAVE TO ASK OUR *NEW CHEF.*

20 MINUTES LATER...

YE'VE POISONED MORE THAN HALF ME CREW!

MAYBE OL' GULL DID TAKE A QUICK BATH IN THE SOUP. BUT YA GOTTA *UNDERSTAND.* I'M A SEAGULL, AND WE'RE ALL PRETTY *FILTHY.* I HAD TO WASH UP *BEFORE COOKING.*

LUCKY FER ME I'M ON A STRICT *ALL-RUM DIET.* AS FOR *YOU*...!

AW, YA *GOTTA* GIVE ME ANOTHER CHANCE! I'M *BEGGIN'* YA!

THE NEXT DAY...

OKAY, NOW I KNOW BEING THE **ONLY FOUR SURVIVING CREW MEMBERS** MIGHT BE KINDA **DEPRESSING**.

BUT THE CAPTAIN HAS MADE ME THE NEW **MORALE OFFICER**, AND I'M HERE TO GIVE YOU A **PEP TALK**.

NOW, EVEN THOUGH MOST OF YOUR FRIENDS ARE **DEAD** AND YOUR WORKLOAD HAS **DOUBLED**, I THINK A **SING-A-LONG** WILL TAKE YOUR MIND OFF YOUR **HARD LABOR** AND **SCURVY**.

♪ PACK UP YOUR TROUBLES IN YOUR OLD KIT BAG AND... ♪

10 MINUTES LATER...

THEY **ALL** COMMITTED SUICIDE BY JUMPING OVER-BOARD?

MAYBE I SHOULD HAVE OPENED WITH A **JOKE**.

I'LL CUT OUT YER **GIBLETS** AND FEED THEM TO THE **SQUID**!

HEY! YOU CAN'T DO THAT! I'M THE ONLY CREW YOU HAVE LEFT.

LOOK, HOW ABOUT MAKING ME THE **NAVIGATOR**? WE SEAGULLS HAVE A NATURAL **SENSE OF DIRECTION**!

5 MINUTES LATER...

AAAAH!

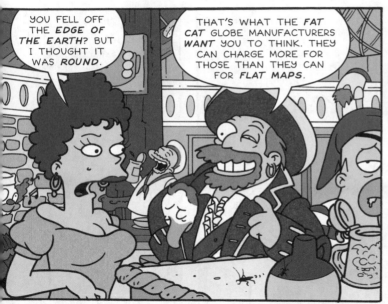

YOU FELL OFF THE *EDGE OF THE EARTH*? BUT I THOUGHT IT WAS *ROUND*.

THAT'S WHAT THE *FAT CAT* GLOBE MANUFACTURERS *WANT* YOU TO THINK. THEY CAN CHARGE MORE FOR THOSE THAN THEY CAN FOR *FLAT MAPS*.

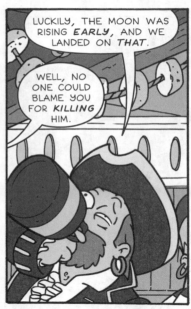

LUCKILY, THE MOON WAS RISING *EARLY*, AND WE LANDED ON *THAT*.

WELL, NO ONE COULD BLAME YOU FOR *KILLING* HIM.

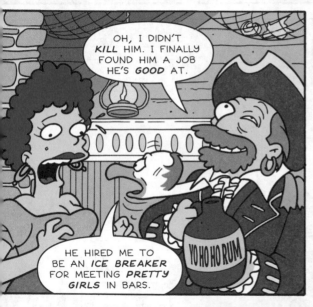

OH, I DIDN'T *KILL* HIM. I FINALLY FOUND HIM A JOB HE'S *GOOD* AT.

HE HIRED ME TO BE AN *ICE BREAKER* FOR MEETING *PRETTY GIRLS* IN BARS.

YO HO HO RUM

THAT IS SO *SWEET*.

OH, AND YOU WANTED ME TO *REMIND* YOU ABOUT YOUR DOCTOR'S APPOINTMENT TOMORROW TO LOOK AT THAT *FULL BODY RASH* YOU PICKED UP IN *BANGKOK*!

EEEEW!

NICE *PIGEON*.

THANKS. Y'KNOW, THERE'S A *FUNNY* STORY ABOUT THAT!

GET BACK HERE! I JUST WANT TO *HUG* YA!

AAAAH!

AROUND THE *NECK*!

UM...*OKAY*. THAT WAS...A *STORY*.

HOW ABOUT *YOU*, DAD? WHAT WAS THE LAST BOOK YOU *READ*?

I DON'T KNOW. IT'S BEEN A WHILE.

DAD... PLEASE?

WELL, OKAY....

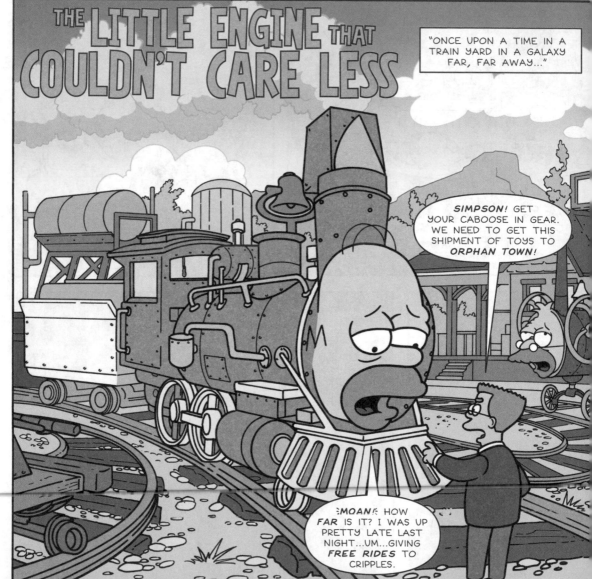

THE LITTLE ENGINE THAT COULDN'T CARE LESS

"ONCE UPON A TIME IN A TRAIN YARD IN A GALAXY FAR, FAR AWAY..."

SIMPSON! GET YOUR CABOOSE IN GEAR. WE NEED TO GET THIS SHIPMENT OF TOYS TO *ORPHAN TOWN!*

≡MOAN≡ HOW *FAR* IS IT? I WAS UP PRETTY LATE LAST NIGHT...UM...GIVING *FREE RIDES* TO CRIPPLES.

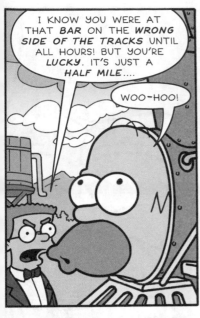

I KNOW YOU WERE AT THAT **BAR** ON THE **WRONG SIDE OF THE TRACKS** UNTIL ALL HOURS! BUT YOU'RE **LUCKY**. IT'S JUST A **HALF MILE**....

WOO-HOO!

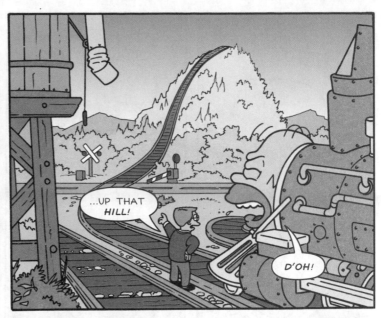

...UP THAT **HILL!**

D'OH!

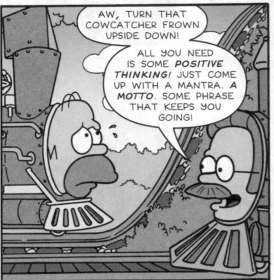

AW, TURN THAT COWCATCHER FROWN UPSIDE DOWN!

ALL YOU NEED IS SOME **POSITIVE THINKING!** JUST COME UP WITH A MANTRA. A **MOTTO**. SOME PHRASE THAT KEEPS YOU GOING!

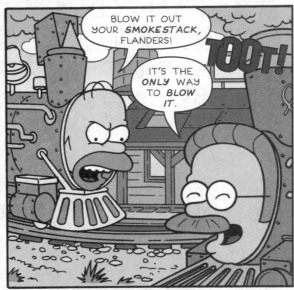

BLOW IT OUT YOUR **SMOKESTACK,** FLANDERS!

IT'S THE **ONLY** WAY TO **BLOW IT.**

TOOT!

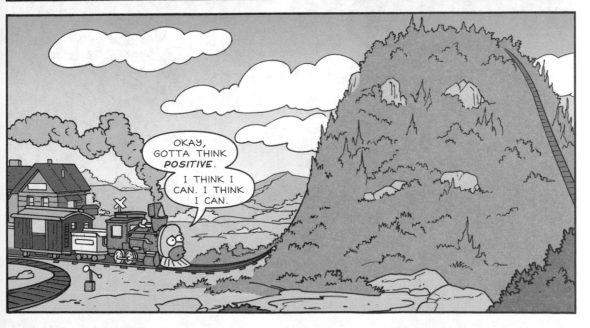

OKAY, GOTTA THINK **POSITIVE**.

I THINK I CAN. I THINK I CAN.

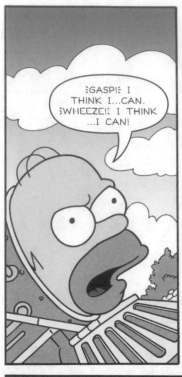

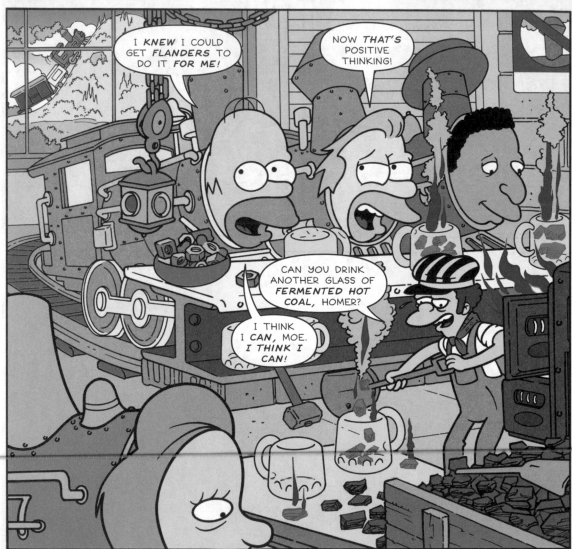

LITTLE WOMEN

HEY! WATCH WHERE YOU'RE WALKING!

OH, SORRY!

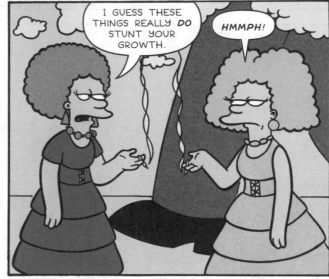

I GUESS THESE THINGS REALLY *DO* STUNT YOUR GROWTH.

HMMPH!

THE 7 HABITS OF HIGHLY SUCCESSFUL KWIK-E-MART EMPLOYEES

1. PRIORITIZE.

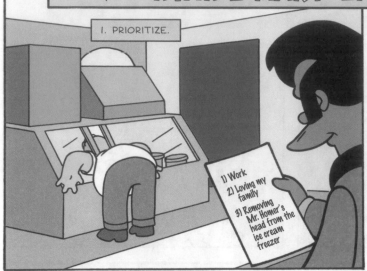

1) Work
2) Loving my family
3) Removing Mr. Homer's head from the ice cream freezer

2. BEGIN WORK WITH NO END IN MIND.

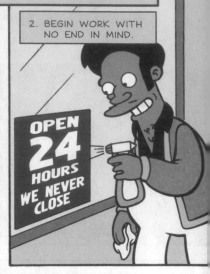

OPEN 24 HOURS WE NEVER CLOSE

3. THINK "WIN-WIN."

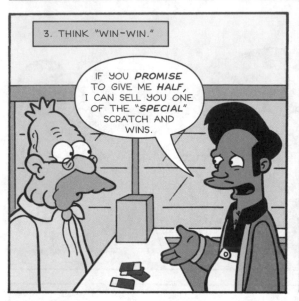

IF YOU *PROMISE* TO GIVE ME *HALF*, I CAN SELL YOU ONE OF THE *"SPECIAL"* SCRATCH AND WINS.

4. SEEK FIRST TO UNDERSTAND, THEN NOT TO BE UNDERSTOOD.

I'D LIKE TO RETURN THIS "SOUP FOR ONE." IT WAS BARELY SOUP FOR *ONE HALF*.

SOUP

YES, SIR, NO, SIR. ENGLISH I NO SPEAK. HOT DOG, HOT DOG!

5. BE PROACTIVE AND...6. SHARPEN THE SAW.

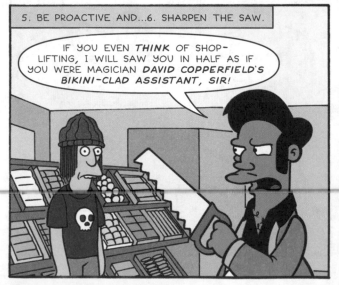

IF YOU EVEN *THINK* OF SHOP-LIFTING, I WILL SAW YOU IN HALF AS IF YOU WERE MAGICIAN *DAVID COPPERFIELD'S* *BIKINI-CLAD* ASSISTANT, SIR!

7. THE ARMED CUSTOMER IS ALWAYS RIGHT.

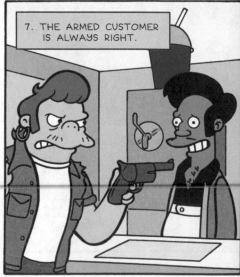

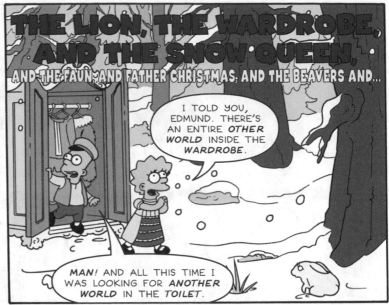

SOON...

GARAGE SALE

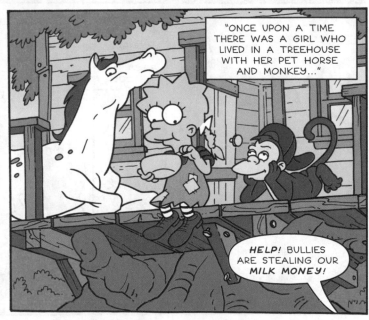

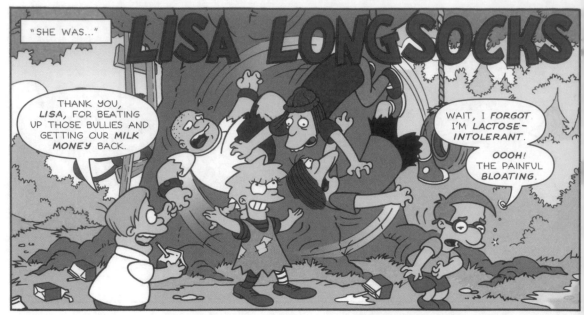

"SHE WAS..." # LISA LONGSOCKS

THANK YOU, *LISA*, FOR BEATING UP THOSE BULLIES AND GETTING OUR *MILK MONEY* BACK.

WAIT, I *FORGOT* I'M *LACTOSE-INTOLERANT.*

OOOH! THE PAINFUL *BLOATING.*

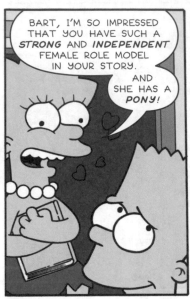

BART, I'M SO IMPRESSED THAT YOU HAVE SUCH A *STRONG* AND *INDEPENDENT* FEMALE ROLE MODEL IN YOUR STORY.

AND SHE HAS A *PONY!*

"OH, AND DID I MENTION SHE HAD A *BROTHER*?"

HEY, SIS! IT'S ME! *BART LONGSOCKS!*

OW!

WHAM!

OOF!

GAH!

I NEED A PLACE TO CRASH. CAN I STAY HERE UNTIL I'M BACK ON MY FEET?

I GUESS SO...AS LONG AS IT'S JUST TEMPORARY.

GREAT. I GAVE MY BAGS TO YOUR *MONKEY BUTLER* AND *PONY MAID.* WHERE'S YOUR *FOOD?*

BUT THEY'RE NOT... BUT I...

LATER...

HOORAY!

SORRY, *BIG-FOOT*, BUT YOU WON'T BE STEALING *PICNIC BASKETS* AROUND HERE ANYMORE!

OUCH!

POW!

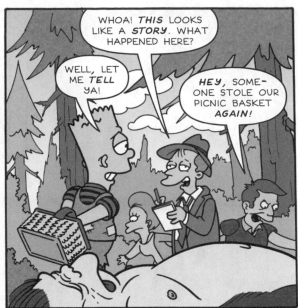
WHOA! *THIS* LOOKS LIKE A *STORY*. WHAT HAPPENED HERE?

WELL, LET ME *TELL* YA!

HEY, SOMEONE STOLE OUR PICNIC BASKET *AGAIN!*

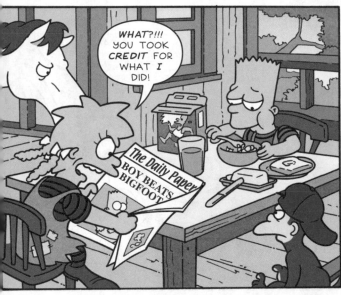
WHAT?!!! YOU TOOK *CREDIT* FOR WHAT *I* DID!

The Daily Paper
BOY BEATS BIGFOOT

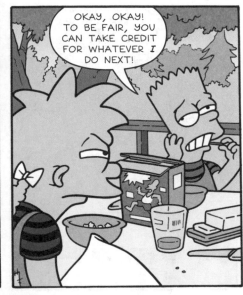
OKAY, OKAY! TO BE FAIR, YOU CAN TAKE CREDIT FOR WHATEVER *I* DO NEXT!

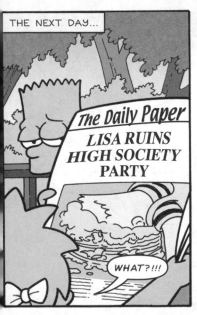
THE NEXT DAY...

The Daily Paper
LISA RUINS HIGH SOCIETY PARTY

WHAT?!!!

AND YOU SET *FIRE* TO *AUSTRALIA?*

NOT ALL OF IT.

THAT *DOES* IT! GET *OUT!*

WHERE AM I SUPPOSED TO GO? MOM'S IN *HEAVEN,* AND DAD'S A *PIRATE* AT SEA.

EXCUSE ME.

¡GASP!¡ YOU CAN TALK?

YES, AND WE QUIT!

QUIT?

WE NEVER AGREED TO BE A MAID AND BUTLER, AND TO BE QUITE FRANK, YOUR BROTHER'S HYGIENE IS HORRIFIC.

AND THAT'S COMING FROM SOMEONE WHO SLEEPS IN A STALL WITH HIS OWN FILTH! GOODBYE!

GRRRR...

AND THAT'S WHY I CALLED THIS EMERGENCY FAMILY MEETING. WE CAN'T WORK THIS OUT OUR-SELVES.

AW, CAN'T THIS WAIT? MY CREW'S FIGHTING OFF BOTH REDBEARD AND BLUEBEARD WITHOUT ME RIGHT NOW!

YES, CAN WE HURRY THIS UP? HEAVEN'S GOT A CURFEW, AND YOU DON'T WANT TO TICK OFF ST. PETER!

WELL, I DON'T CARE WHAT ANY OF YOU SAY!

I LIKE IT HERE, AND I'M NOT LEAVING UNTIL I FIND FAME AND FORTUNE!

THEN I'LL GO LIVE WITH MOM.

FINE, WHAT-EVER. JUST GRAB MY ROBE. I GOTTA GO BEFORE THEY LOCK THE PEARLY GATES.

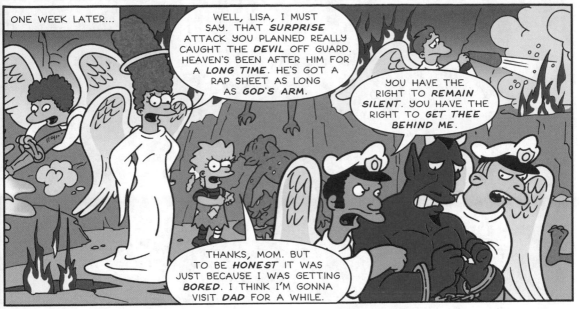

ONE WEEK LATER...

WELL, LISA, I MUST SAY. THAT *SURPRISE* ATTACK YOU PLANNED REALLY CAUGHT THE *DEVIL* OFF GUARD. HEAVEN'S BEEN AFTER HIM FOR A *LONG TIME*. HE'S GOT A RAP SHEET AS LONG AS *GOD'S ARM*.

YOU HAVE THE RIGHT TO *REMAIN SILENT*. YOU HAVE THE RIGHT TO *GET THEE BEHIND ME*.

THANKS, MOM. BUT TO BE *HONEST* IT WAS JUST BECAUSE I WAS GETTING *BORED*. I THINK I'M GONNA VISIT *DAD* FOR A WHILE.

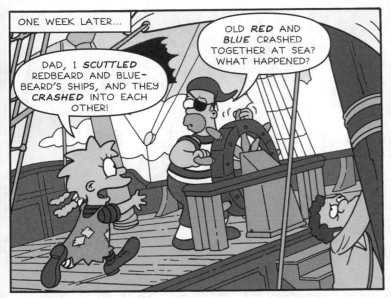

ONE WEEK LATER...

DAD, I *SCUTTLED* REDBEARD AND BLUE-BEARD'S SHIPS, AND THEY *CRASHED* INTO EACH OTHER!

OLD *RED* AND *BLUE* CRASHED TOGETHER AT SEA? WHAT HAPPENED?

THEY WERE *MAROONED!*

I DON'T *GET IT*.

:SIGH: I'M GOING *HOME*.

AH, THE *GOOD OLD FOREST*. I CAN'T WAIT TO SEE WHAT KIND OF *MESS* BART'S GOTTEN INTO.

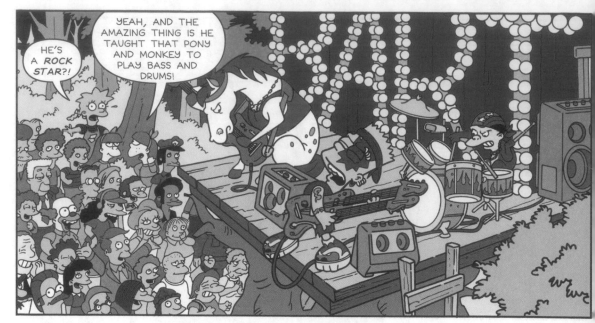

HE'S A *ROCK STAR*?!

YEAH, AND THE AMAZING THING IS HE TAUGHT THAT PONY AND MONKEY TO PLAY BASS AND DRUMS!

WELL, HE SURE SHOWED *ME*! I GUESS NO MATTER WHAT *GIRLS DO*, THEY'LL *NEVER BE BETTER THAN BOYS*.

THAT WAS THE TITLE OF HIS FIRST *HIT SINGLE*!

WHAT?!!! THAT'S THE MORAL TO YOUR STORY? *BOYS ARE BETTER THAN GIRLS*?

I JUST CALL 'EM AS I SEE 'EM, LIS.

FINE. THEN HERE'S A STORY THAT HAS A *BOY* IN IT, BART. A BOY *MUCH LIKE YOU* THAT VISITS A CARNIVAL. I CALL IT...

SOMETHING PRETTY BAD THIS WAY IS COMING!

SIDESHOW BOB & KRUSTY'S **PANDEMONIUM SHOW** NO ACTUAL PANDAS WILL PERFORM

THANKS FOR TAKING US TO THE *CARNIVAL*, DAD.

NO PROBLEMO. Y'KNOW, I USED TO COME TO CARNIVALS LIKE THIS WHEN I WAS *YOUR* AGE.

MAN, THOSE WERE *CAREFREE DAYS*. I'D GIVE *ANYTHING* TO BE A KID AGAIN.

HALL OF MIRRORS

AAAAH! MY FACE! *AND THOSE HORRIBLE REFLECTIONS!* AAAAAH!

WOW, THE *HALL OF MIRRORS* DROVE OUR TEACHER MAD.

WELL, BOO-HOO! *WE* HAVE TO LOOK AT HER FACE SIX HOURS A DAY, FIVE DAYS A WEEK!

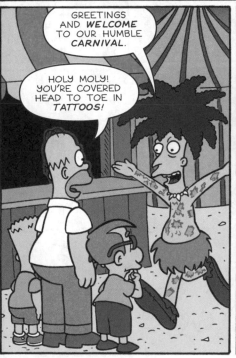

GREETINGS AND *WELCOME* TO OUR HUMBLE *CARNIVAL*.

HOLY MOLY! YOU'RE COVERED HEAD TO TOE IN *TATTOOS!*

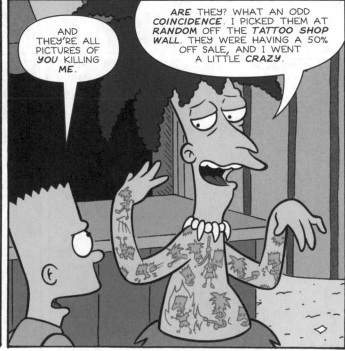

AND THEY'RE ALL PICTURES OF *YOU* KILLING *ME*.

ARE THEY? WHAT AN ODD *COINCIDENCE*. I PICKED THEM AT *RANDOM* OFF THE *TATTOO SHOP WALL*. THEY WERE HAVING A 50% OFF SALE, AND I WENT A LITTLE *CRAZY*.

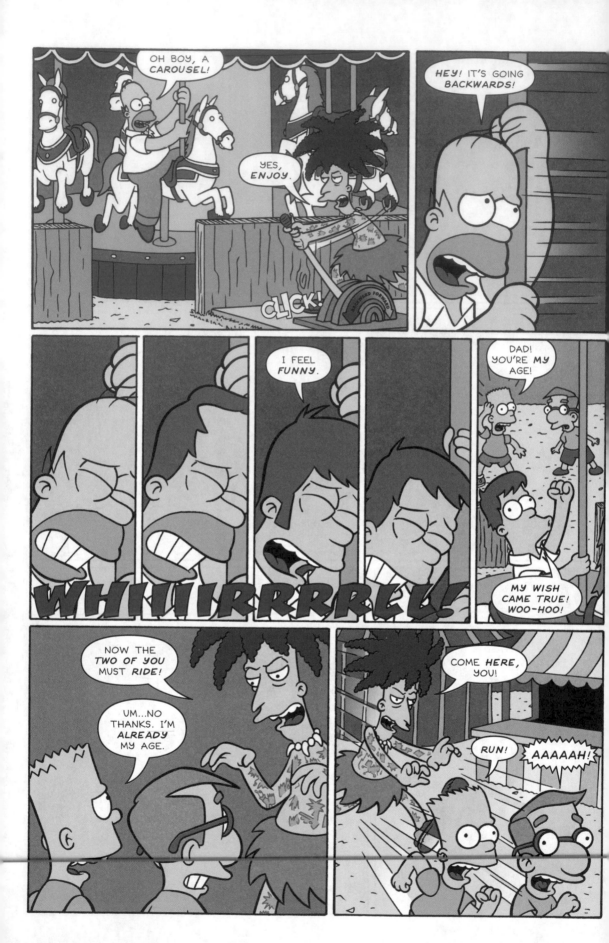

LET'S HIDE IN THE *SEWER!*

WHAT IS IT WITH *YOU* AND SEWERS?

I–I JUST LIKE THEM IS ALL.

LOOK AT ALL THE *BABY ALLIGATORS!*

HEY! IS ANYONE *DOWN* THERE?

DAD ARE YOU *OKAY?*

YEAH, BUT I THINK SIDESHOW BOB IS *EVIL.* HE DROPPED HIS *UNION CARD.*

EVIL UNION LOCAL 13

YOU GOTTA HIDE DOWN HERE WITH US!

NAW, I'LL JUST HIDE AT MOE'S AND HAVE A *FEW BEERS* UNTIL THIS ALL BLOWS OVER.

DAD, YOU'RE *MY AGE.* YOU CAN'T DRINK FOR *ELEVEN YEARS!*

NO *BEER?* FOR *ELEVEN YEARS?!*

NOOOOO!

SHOULDN'T YOU BE DOING *HOME-WORK* AT THIS HOUR, YOUNG MAN, INSTEAD OF RUNNING DOWN THE STREET *YELLING* IN *TERROR?*

EXCUSE ME, SIR, HAVE YOU SEEN *THESE BOYS?*

¡GASP!

I DON'T KNOW. THOSE ARE *TERRIBLE* LIKENESSES.

WELL, *YOU* TRY TATTOOING YOUR OWN *PALMS*.

WHY DIDN'T YOU JUST BRING *PHOTOS* OF THE BOYS?

YOU KNOW, I NEVER *THOUGHT* OF THAT.

MEMO TO SELF...

CLICK!

HE'S DISTRACTED! *RUN FOR IT!*

DAD! GOOD TO SEE YOU! WE'VE GOT TO GET BACK TO THE CARNIVAL AND *REVERSE THE SPELL!*

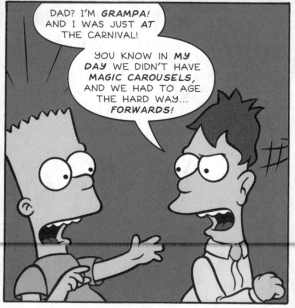

DAD? I'M *GRAMPA!* AND I WAS JUST *AT* THE CARNIVAL!

YOU KNOW IN *MY DAY* WE DIDN'T HAVE *MAGIC CAROUSELS*, AND WE HAD TO AGE THE HARD WAY... *FORWARDS!*

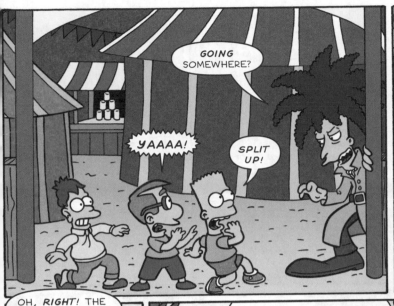

GOING SOMEWHERE?

YAAAA!

SPLIT UP!

OF MIRRORS

I'LL BE *SAFE* IN HERE!

OH, *RIGHT!* THE *HORRIFYING* REFLECTIONS.

I MEAN...

AAAAH!

I'M NEVER BUYING A *USED CURSED CAROUSEL* AGAIN. IT'S ALWAYS *BREAKING DOWN.*

AND IF I HAVE TO HEAR *"POP GOES THE WEASEL"* BACKWARDS AGAIN, I'LL GO *MESHUGGENAH!*

BUMP!

YAAAA!

OH MY GOSH! YOU LOOK A *HUNDRED AND FIFTY YEARS OLD!*

YEAH, BUT ON MY *RESUMÉ,* I'LL SAY I'M A *HUNDRED.*

LISTEN, BART, IF YOU COME PEACEFULLY, I'LL LET YOU PICK YOUR DEATH FROM ONE OF MY *TATTOOS.* IT'LL BE LIKE ORDERING OFF A *MENU!*

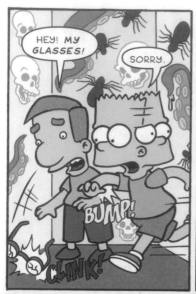

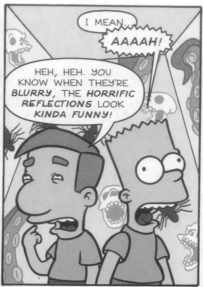

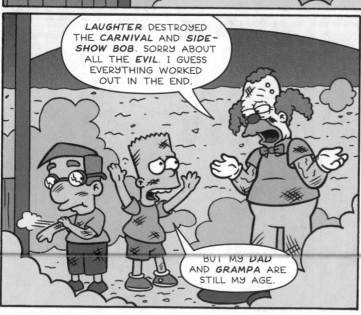

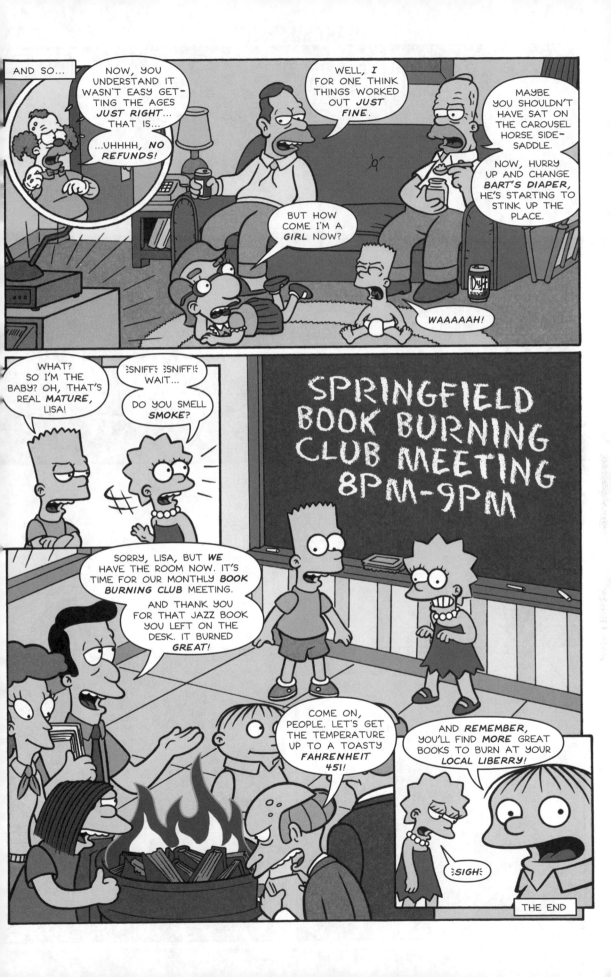

BART SIMPSON (in)
DOWN IN THE DUMPS

AAAAAAAH!

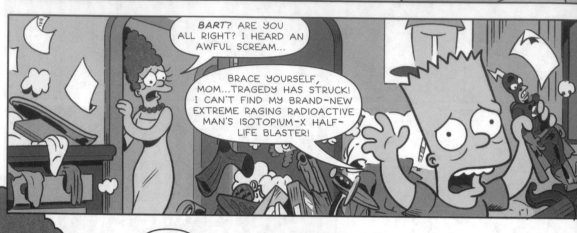

BART? ARE YOU ALL RIGHT? I HEARD AN AWFUL SCREAM...

BRACE YOURSELF, MOM...TRAGEDY HAS STRUCK! I CAN'T FIND MY BRAND-NEW EXTREME RAGING RADIOACTIVE MAN'S ISOTOPIUM-X HALF-LIFE BLASTER!

OH, IS *THAT* ALL?

IS THAT ALL? THE ISOTOPIUM-X BLASTER IS THE MOST OFFENSIVE RADIOACTIVE MAN ACCESSORY *EVER!* IT LIGHTS UP AND GOES VWIZZZZ AND SHA-BOOMSH AND MUTILATES YOUR ENEMIES! MELTS THEIR FACES AND EVERYTHING!

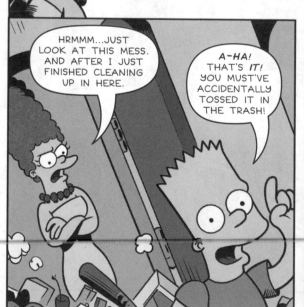

HRMMM...JUST LOOK AT THIS MESS. AND AFTER I JUST FINISHED CLEANING UP IN HERE.

A-HA! THAT'S *IT!* YOU MUST'VE ACCIDENTALLY TOSSED IT IN THE TRASH!

HEY, BART, WE WERE JUST-- :OOFTA!:

OUTTA MY WAY! I'M ON A RESCUE MISSION!

OWIE! MY DAINTY STERNUM!

EVAN DORKIN
SCRIPT

JOHN DELANEY
PENCILS

DAN DAVIS
INKS

ROBERT STANLEY
COLORS

KAREN BATES
LETTERS

BILL MORRISON
EDITOR

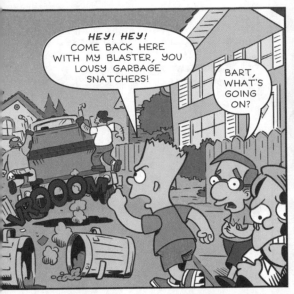

HEY! HEY! COME BACK HERE WITH MY BLASTER, YOU LOUSY GARBAGE SNATCHERS!

BART, WHAT'S GOING ON?

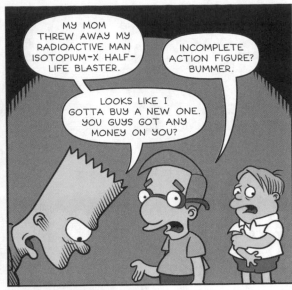

MY MOM THREW AWAY MY RADIOACTIVE MAN ISOTOPIUM-X HALF-LIFE BLASTER.

INCOMPLETE ACTION FIGURE? BUMMER.

LOOKS LIKE I GOTTA BUY A NEW ONE. YOU GUYS GOT ANY MONEY ON YOU?

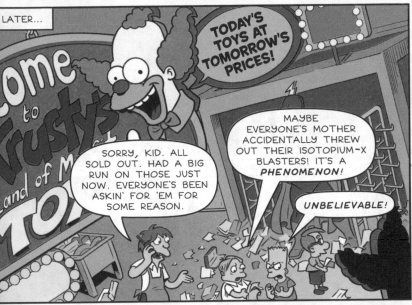

LATER...

TODAY'S TOYS AT TOMORROW'S PRICES!

SORRY, KID. ALL SOLD OUT. HAD A BIG RUN ON THOSE JUST NOW. EVERYONE'S BEEN ASKIN' FOR 'EM FOR SOME REASON.

MAYBE EVERYONE'S MOTHER ACCIDENTALLY THREW OUT THEIR ISOTOPIUM-X BLASTERS! IT'S A PHENOMENON!

UNBELIEVABLE!

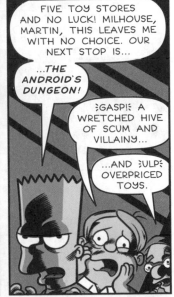

FIVE TOY STORES AND NO LUCK! MILHOUSE, MARTIN, THIS LEAVES ME WITH NO CHOICE. OUR NEXT STOP IS...

...THE ANDROID'S DUNGEON!

¡GASP!¡ A WRETCHED HIVE OF SCUM AND VILLAINY...

...AND ¡GULP!¡ OVERPRICED TOYS.

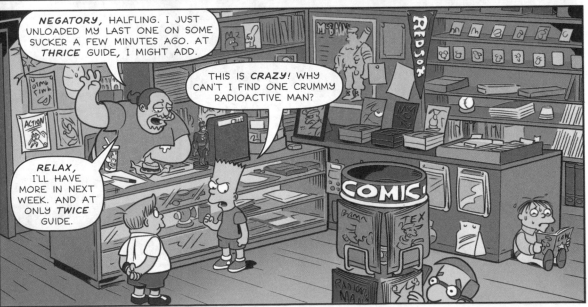

NEGATORY, HALFLING. I JUST UNLOADED MY LAST ONE ON SOME SUCKER A FEW MINUTES AGO. AT THRICE GUIDE, I MIGHT ADD.

THIS IS CRAZY! WHY CAN'T I FIND ONE CRUMMY RADIOACTIVE MAN?

RELAX, I'LL HAVE MORE IN NEXT WEEK. AND AT ONLY TWICE GUIDE.

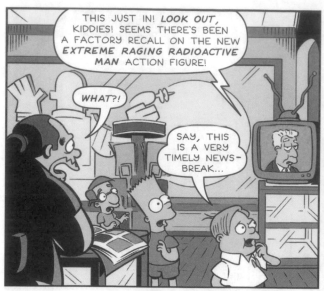
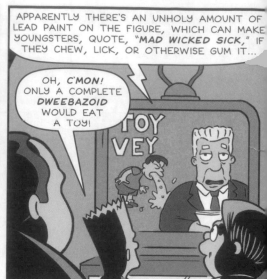
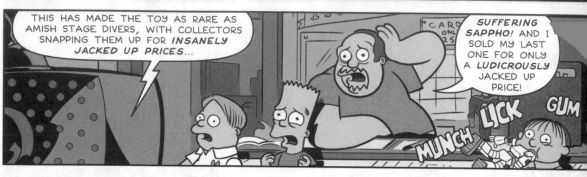
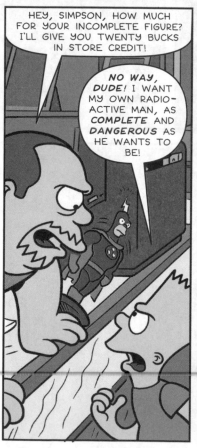
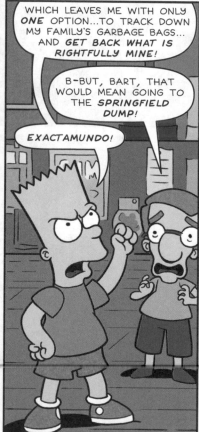
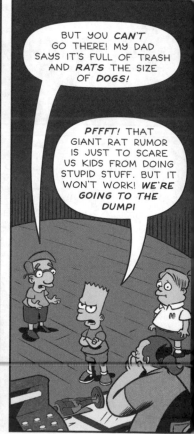

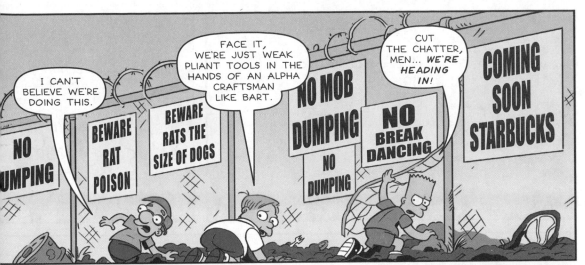

NO DUMPING

BEWARE RAT POISON

BEWARE RATS THE SIZE OF DOGS

NO MOB DUMPING
NO DUMPING

NO BREAK DANCING

COMING SOON STARBUCKS

I CAN'T BELIEVE WE'RE DOING THIS.

FACE IT, WE'RE JUST WEAK PLIANT TOOLS IN THE HANDS OF AN ALPHA CRAFTSMAN LIKE BART.

CUT THE CHATTER, MEN... WE'RE HEADING IN!

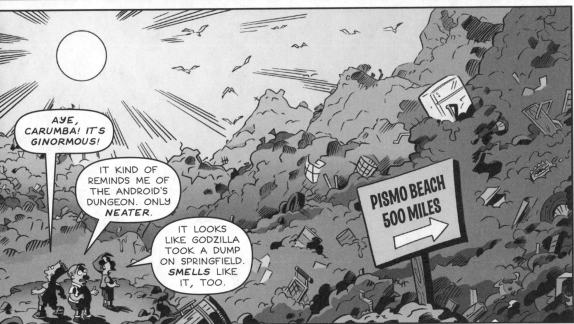

AYE, CARUMBA! IT'S GINORMOUS!

IT KIND OF REMINDS ME OF THE ANDROID'S DUNGEON. ONLY NEATER.

IT LOOKS LIKE GODZILLA TOOK A DUMP ON SPRINGFIELD. SMELLS LIKE IT, TOO.

PISMO BEACH 500 MILES

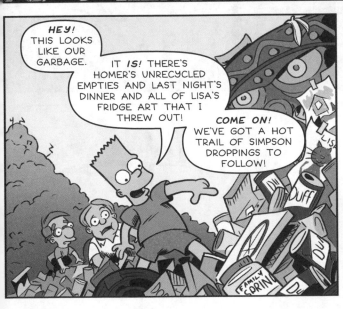

HEY! THIS LOOKS LIKE OUR GARBAGE.

IT IS! THERE'S HOMER'S UNRECYCLED EMPTIES AND LAST NIGHT'S DINNER AND ALL OF LISA'S FRIDGE ART THAT I THREW OUT!

COME ON! WE'VE GOT A HOT TRAIL OF SIMPSON DROPPINGS TO FOLLOW!

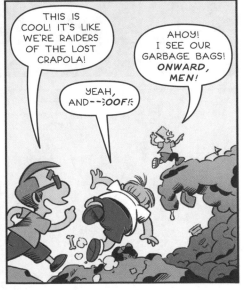

THIS IS COOL! IT'S LIKE WE'RE RAIDERS OF THE LOST CRAPOLA!

AHOY! I SEE OUR GARBAGE BAGS! ONWARD, MEN!

YEAH, AND--OOF!

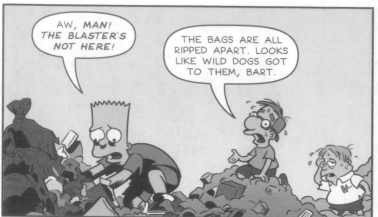

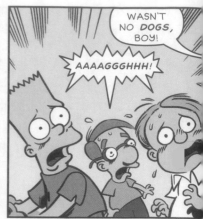

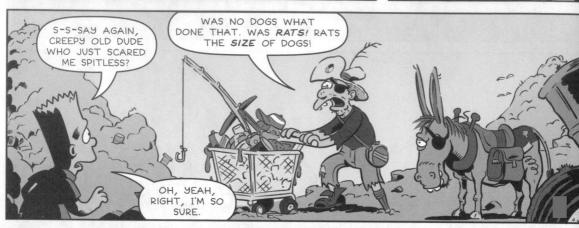

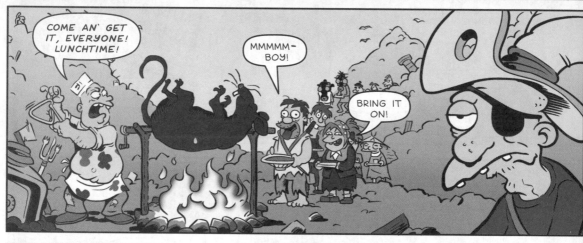

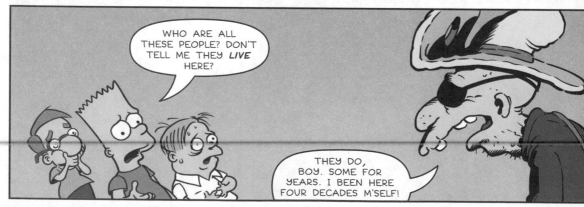

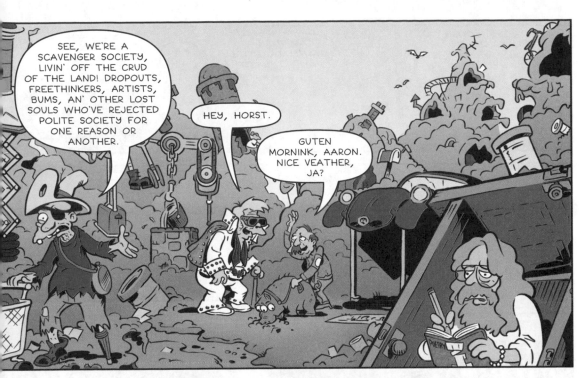

SEE, WE'RE A SCAVENGER SOCIETY, LIVIN' OFF THE CRUD OF THE LAND! DROPOUTS, FREETHINKERS, ARTISTS, BUMS, AN' OTHER LOST SOULS WHO'VE REJECTED POLITE SOCIETY FOR ONE REASON OR ANOTHER.

HEY, HORST.

GUTEN MORNINK, AARON. NICE VEATHER, JA?

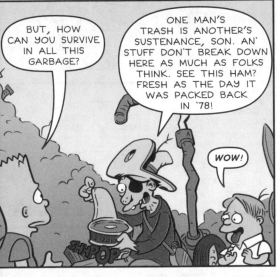

BUT, HOW CAN YOU SURVIVE IN ALL THIS GARBAGE?

ONE MAN'S TRASH IS ANOTHER'S SUSTENANCE, SON. AN' STUFF DON'T BREAK DOWN HERE AS MUCH AS FOLKS THINK. SEE THIS HAM? FRESH AS THE DAY IT WAS PACKED BACK IN '78!

WOW!

PEE-*YOOO! MARTIN!*

IT WASN'T ME...*HONEST!*

THAT'S A METHANE VENT! LETS BUILT-UP GAS ESCAPE WIT'OUT BLOWIN' THE PLACE SKY-HIGH. STEER CLEAR OF 'EM, BOYS. THEY'S DANGEROUS!

SO, WHAT BRINGS YOU YOUNGSTERS HERE? FAMILY STRIFE? BUSINESS TROUBLES? THE FEDS?

NAH. WE'RE LOOKING FOR A TOY MY MOM THREW OUT.

TOYS, EH? *HMM.* Y'KNOW, BOYS, THEY SAY SOMEWHERE IN THIS VAST WASTELAND IS A HUGE TREASURE HEAP OF OLD STUFF GOIN' BACK TO THE GOLDEN AGE OF AMERICA.

WHOA. THAT'S LIKE, *OLD,* RIGHT, OLD DUDE?

LIKE OLD GOLDEN AGE COMIC BOOKS?

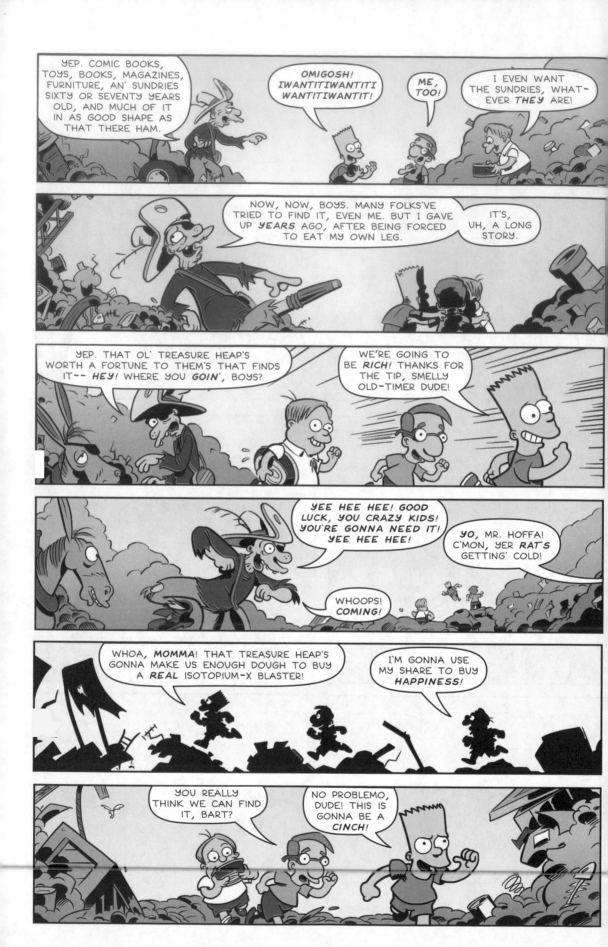

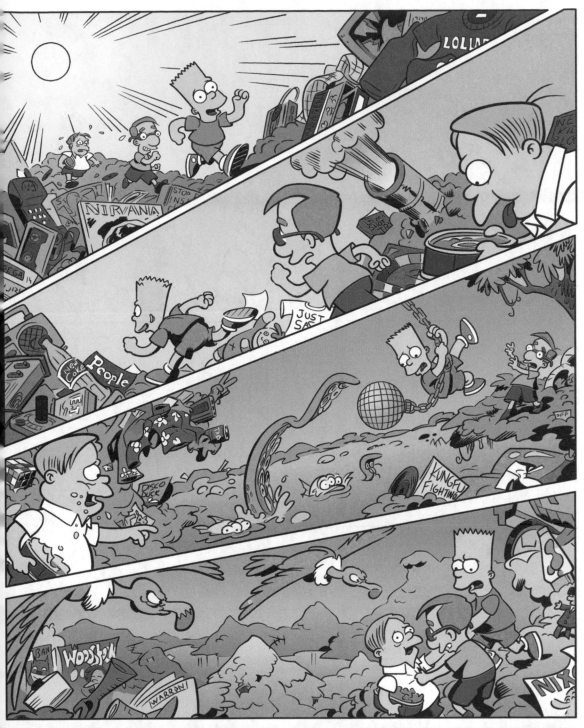
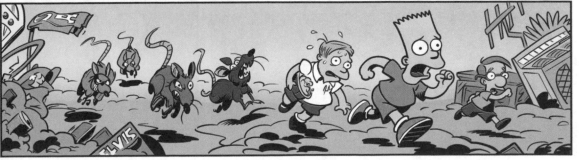

UNTOLD HOURS LATER...

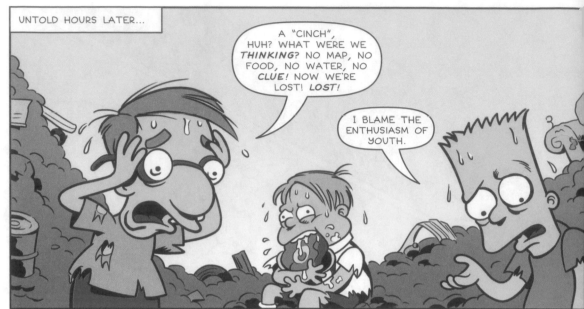

A "CINCH", HUH? WHAT WERE WE *THINKING*? NO MAP, NO FOOD, NO WATER, NO *CLUE*! NOW WE'RE LOST! *LOST*!

I BLAME THE ENTHUSIASM OF YOUTH.

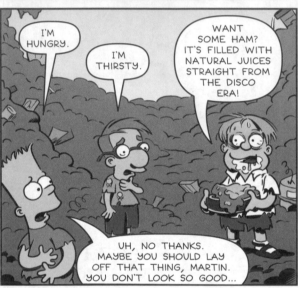

I'M HUNGRY.

I'M THIRSTY.

WANT SOME HAM? IT'S FILLED WITH NATURAL JUICES STRAIGHT FROM THE DISCO ERA!

UH, NO THANKS. MAYBE YOU SHOULD LAY OFF THAT THING, MARTIN. YOU DON'T LOOK SO GOOD...

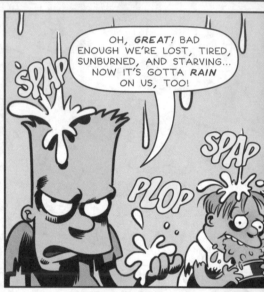

OH, *GREAT*! BAD ENOUGH WE'RE LOST, TIRED, SUNBURNED, AND STARVING... NOW IT'S GOTTA *RAIN* ON US, TOO!

SPAP

SPAP

PLOP

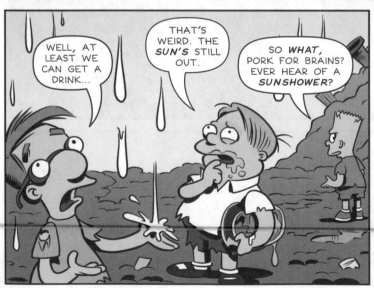

WELL, AT LEAST WE CAN GET A DRINK...

THAT'S WEIRD. THE *SUN'S* STILL OUT.

SO *WHAT*, PORK FOR BRAINS? EVER HEAR OF A *SUNSHOWER*?

UM, GUYS...? THIS IS NO SUN-SHOWER.

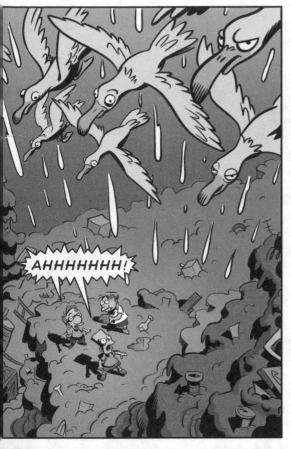

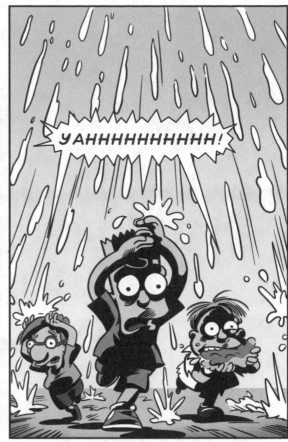

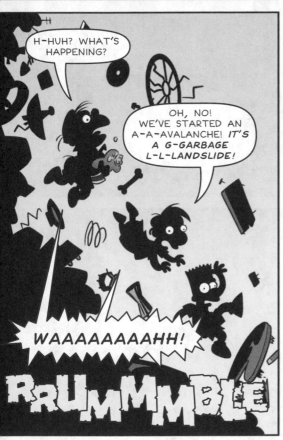

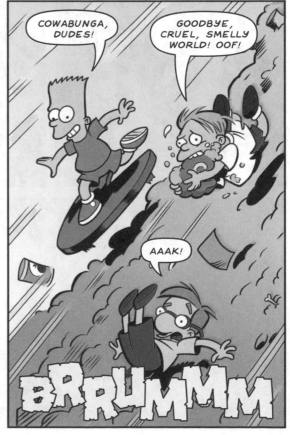

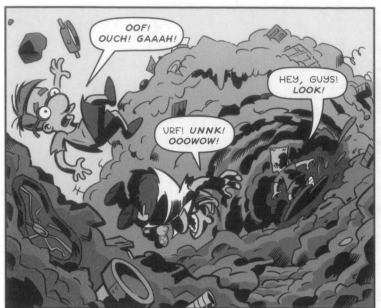

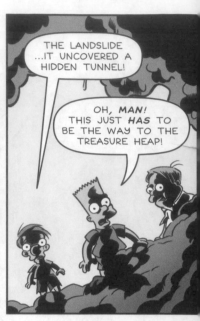

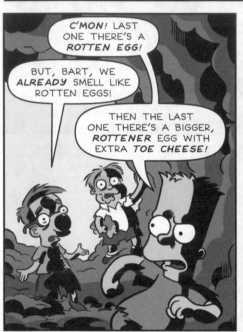

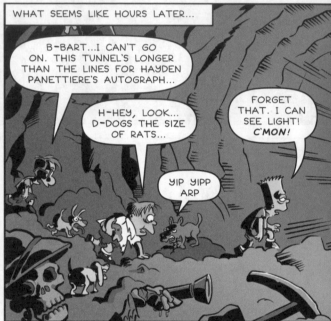

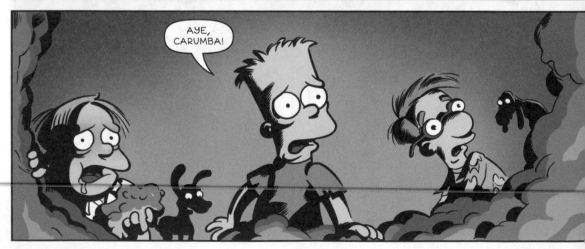

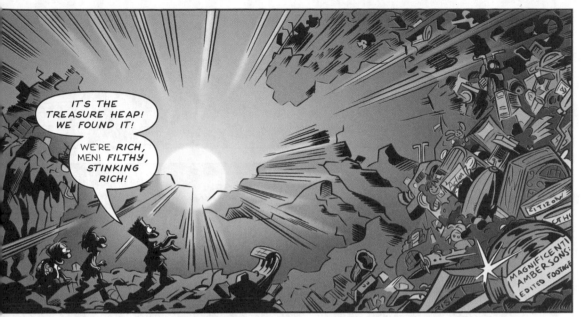

IT'S THE TREASURE HEAP! WE FOUND IT!

WE'RE *RICH*, MEN! *FILTHY*, STINKING *RICH*!

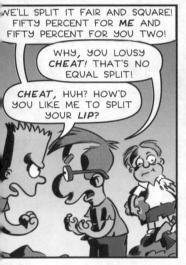

WE'LL SPLIT IT FAIR AND SQUARE! FIFTY PERCENT FOR *ME* AND FIFTY PERCENT FOR YOU TWO!

WHY, YOU LOUSY *CHEAT*! THAT'S NO EQUAL SPLIT!

CHEAT, HUH? HOW'D YOU LIKE ME TO SPLIT YOUR *LIP*?

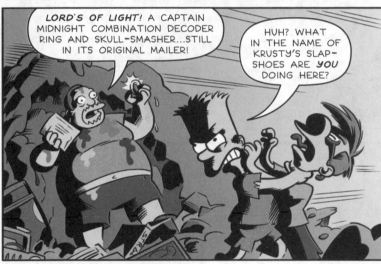

LORD'S OF LIGHT! A CAPTAIN MIDNIGHT COMBINATION DECODER RING AND SKULL-SMASHER...STILL IN ITS ORIGINAL MAILER!

HUH? WHAT IN THE NAME OF KRUSTY'S SLAP-SHOES ARE *YOU* DOING HERE?

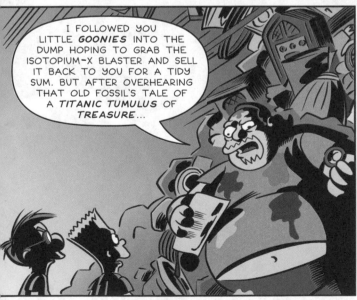

I FOLLOWED YOU LITTLE *GOONIES* INTO THE DUMP HOPING TO GRAB THE ISOTOPIUM-X BLASTER AND SELL IT BACK TO YOU FOR A TIDY SUM. BUT AFTER OVERHEARING THAT OLD FOSSIL'S TALE OF A *TITANIC TUMULUS* OF *TREASURE*...

YOU FIGURED YOU'D DOG OUR TRAIL AND BUST IN ON OUR ACTION.

CORRECT, IF A TRIFLE VULGAR.

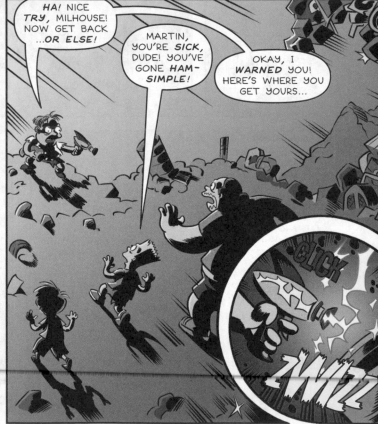

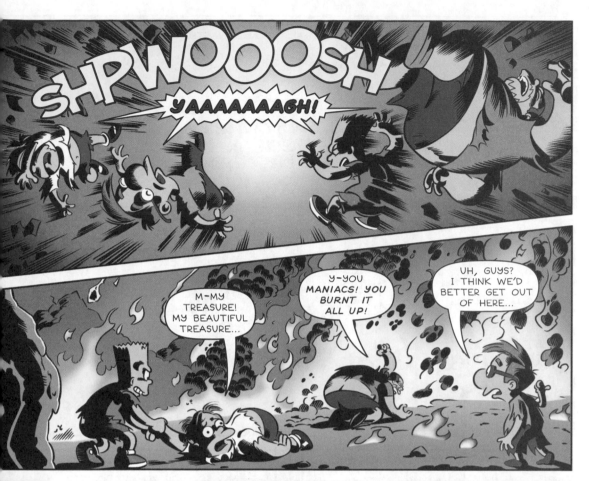

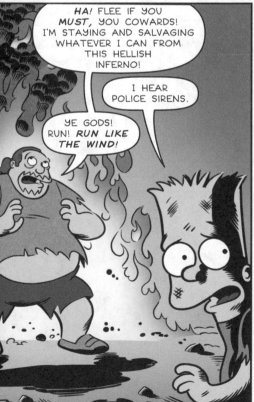

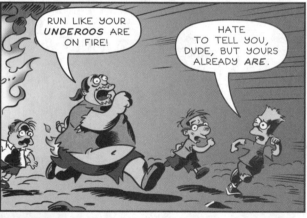

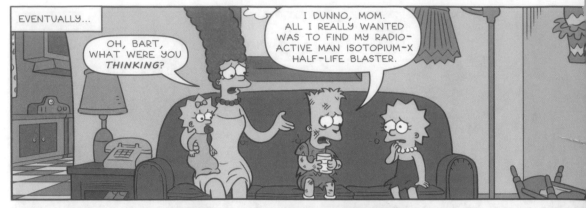

EVENTUALLY...

OH, BART, WHAT WERE YOU *THINKING*?

I DUNNO, MOM. ALL I REALLY WANTED WAS TO FIND MY RADIO-ACTIVE MAN ISOTOPIUM-X HALF-LIFE BLASTER.

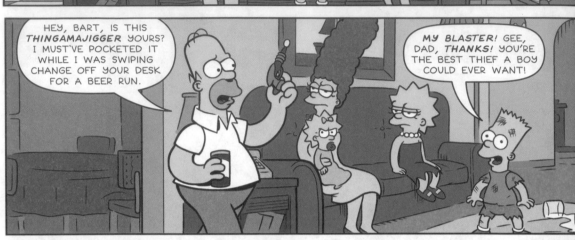

HEY, BART, IS THIS *THINGAMAJIGGER* YOURS? I MUST'VE POCKETED IT WHILE I WAS SWIPING CHANGE OFF YOUR DESK FOR A BEER RUN.

MY BLASTER! GEE, DAD, *THANKS!* YOU'RE THE BEST THIEF A BOY COULD EVER WANT!

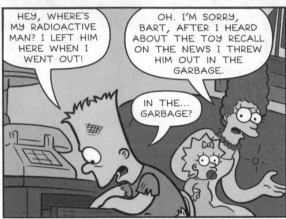

HEY, WHERE'S MY RADIOACTIVE MAN? I LEFT HIM HERE WHEN I WENT OUT!

OH. I'M SORRY, BART, AFTER I HEARD ABOUT THE TOY RECALL ON THE NEWS I THREW HIM OUT IN THE GARBAGE.

IN THE... GARBAGE?

AHHH...WHAT'S A LITTLE *LEAD* GONNA DO? NEXT THEY'LL BE SAYING STEROIDS ARE BAD FOR YOU. *G'WAN*, BOY, GO FETCH HIM OUTTA THE TRASH.

T-T-*TRASH*? G-G-GUH-*GARBAGE*...?

AAAAAAAAH!

THE END

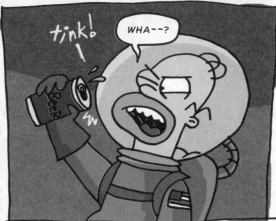

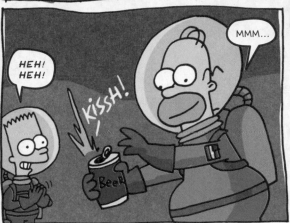

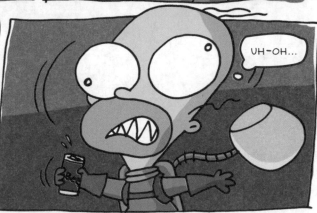

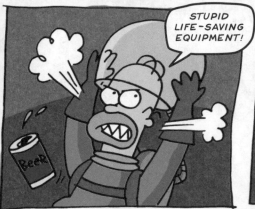

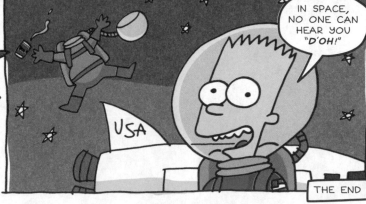

TERRY DELEGEANE
SCRIPT

JASON HO
ART

SERBAN CRISTESCU
COLOR/LETTERS

NATHAN KANE
EDITOR